Painting
WITH OILS

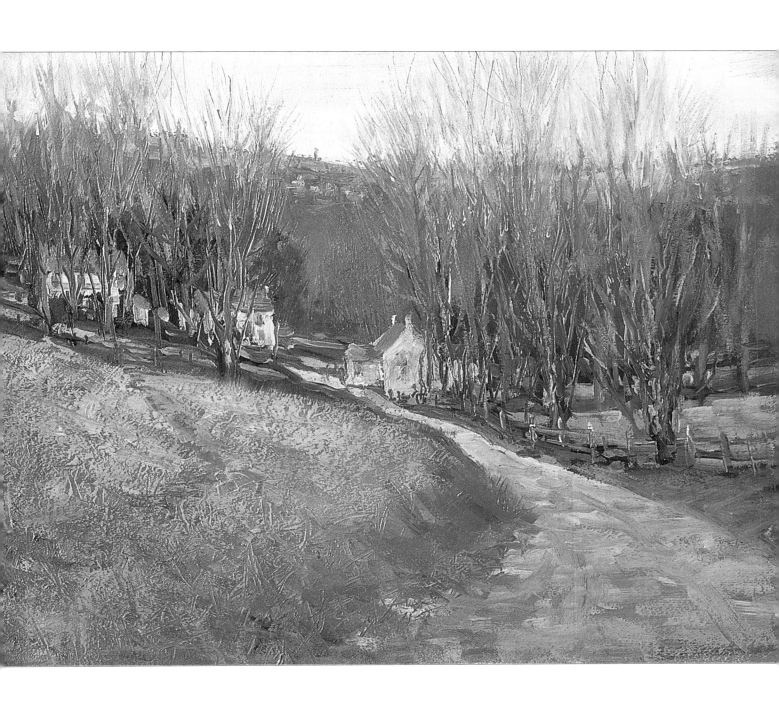

I would like to dedicate this book to all the lovely, friendly people who attend my classes, and whose feedback and comments have helped me with its contents. Thank you all; you know who you are!

Painting WITH OILS

Michael Sanders

SEARCH PRESS

First published in Great Britain 2005

Search Press Limited
Wellwood, North Farm Road,
Tunbridge Wells, Kent TN2 3DR

Text copyright © Michael Sanders 2005

Photographs by Steve Crispe, Search Press Studios

Product photographs on pages 10, 11, 12, 13, 14 and 17 supplied by Winsor & Newton

Photographs and design copyright © Search Press Ltd. 2005

ISBN 1 84448 007 0

The Publishers and author can accept no responsibility for any consequences arising from the information, advice or instructions given in this publication.

Suppliers
If you have difficulty in obtaining any of the materials and equipment mentioned in this book, please visit the Search Press website for details of suppliers: www.searchpress.com

Alternatively, you can write to the Publishers at the address above, for a current list of stockists, including firms which operate a mail-order service; or you can write to Winsor & Newton, requesting a list of distributers.

Winsor & Newton, UK Marketing
Whitefriars Avenue, Harrow,
Middlesex, HA3 5RH

Publishers' note

All the step-by-step photographs in this book feature the author, Michael Sanders, demonstrating how to paint in oils. No models have been used.

There are references to animal hair brushes in this book. It is the publishers' custom to recommend synthetic materials as substitutes for animal products wherever possible. There is now a large range of brushes available made from artificial fibres, and they are satisfactory substitutes for those made from natural fibres.

Manufactured by Universal Graphics Pte Ltd, Singapore

Printed in Malaysia by Times Offset (M) Sdn Bhd

Acknowledgements

I would like to thank Lotti, Juan, Roz and especially Sophie for all their input, good humour and encouragement with this book. It has been, as ever, a pleasure to paint and write, knowing my work is in such safe hands.

Cover:
Lavender Fields
41.5 x 36.5cm (16³/₈ x 14³/₈in)

This painting is a compilation of various elements, combined to make a satisfying and pleasant image. The hilltop town was taken from my sketchbook, as were the mountains in the background. The lavender was taken mainly from my own photographs, apart from the foreground plants, which were painted from life. I set some flowering potted lavender up as a still life in the studio, so I could examine the spiky nature of this evocative plant. The group of houses at the bottom of the field and the path are pure invention.

Page 1:
A Tamar Valley Hamlet
305 x 254mm (12 x 10in)

I am pleased with the way this little painting turned out. Winter trees can look very stark but the addition of pale pink and violet has a softening effect, creating a peaceful, nostalgic look.

Pages 2–3:
Walkers on the Moor
407 x 305mm (16 x 12in)

The shape and texture of wild places have always interested me, particularly when compared to the insignificance of the occasional human being. There is often a strange incongruity between the bright colours favoured by many hikers and the subtle hues of moorland. I try to get out and paint on the moors regularly, and sometimes I can spend the whole day and see or hear no one.

Opposite:
Cornish Evening
267 x 203mm (10½ x 8in)

This image uses the sgraffito technique – or scraping out – to good effect. The sky was painted as an unbroken area on top of dark primer, then a knife was used to scratch out the shape of the tree.

CONTENTS

INTRODUCTION 6

MATERIALS 8

COLOUR 18

TECHNIQUES 26

COMPOSITION 32

STEP-BY-STEP
DEMONSTRATIONS 42

Landscape in Three Colours 44

Still Life 58

Daffodils 64

Fishermen 74

Richmond Hill 86

INDEX 96

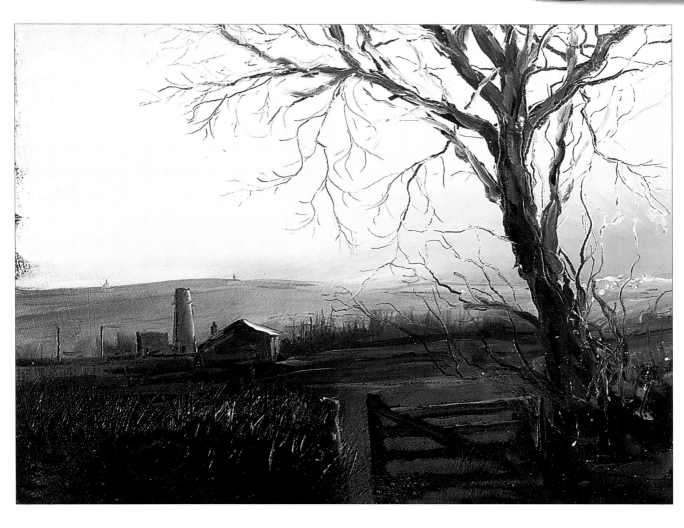

INTRODUCTION

I was pleased and excited to be asked to write this book, for two reasons. First, it gives me the chance to share my enthusiasm for oil paint with you. Secondly, I have the opportunity to dispel some myths about painting with this, the most traditional yet versatile and adventurous of mediums.

I work and teach in a wide range of materials and techniques. Of all of them, I find oil paint is the most consistently misunderstood. There often seems to be a reluctance to get involved, as if the subject is complicated or expensive, or needs vast amounts of space and time in order to produce successful paintings. Most beginners try watercolours first, assuming that it will be simpler and easier to get results. Nothing could be further from the truth. Oils have a versatility of use, and, more importantly, an ease of correction, like nothing else. Mistakes are so easy to rectify, it takes the anxiety out of making art!

In this book I will show you how to plan your paintings so that they are constructed on sound principles rather than left to chance, and you will be taken step by step through the processes of composition, combining colours to achieve a mood or atmosphere, as well as choice of materials, brushes and canvases.

In these pages you'll find lots of tips and techniques, useful for the beginner and the more advanced artist. Some of these are my own discoveries, arrived at after making mistakes and learning from them. Others are gleaned from many sources: reading books written by the old masters, watching experts at work, talking to other painters, sharing experiences.

Art is like that. There is always more to explore, to look at, to enjoy.

As you read this book, perhaps working through the examples, step by step, I hope that you find yourself captivated, enthralled and enthused by the wonderful world that is oil painting, as I am. I hope you have fun.

Don't be put off by the inevitable mistakes; they will teach you more than your successes. Keep a written record of colour mixes that you enjoy, and ones that didn't work. Use as much bold creativity as you can; don't be timid, especially with colour.

The techniques I teach are a springboard for you to develop your own unique style. Experiment, make friends with your paint, and most of all, enjoy it!

Bere Peninsula, Evening

407 x 305mm (16 x 12in)

This painting was made from a tiny sketch that I drew on the back of a business card, as I did not have my usual sketchpad handy. I was very impressed by the strong autumnal colours, combined with the sunset and the shimmery expanse of water. This is where the estuaries of the Tavy and Tamar rivers meet, a place I have known since I was a boy. After seeing this view when driving, I took my little sketch home and painted it immediately while the colours were fresh in my mind.

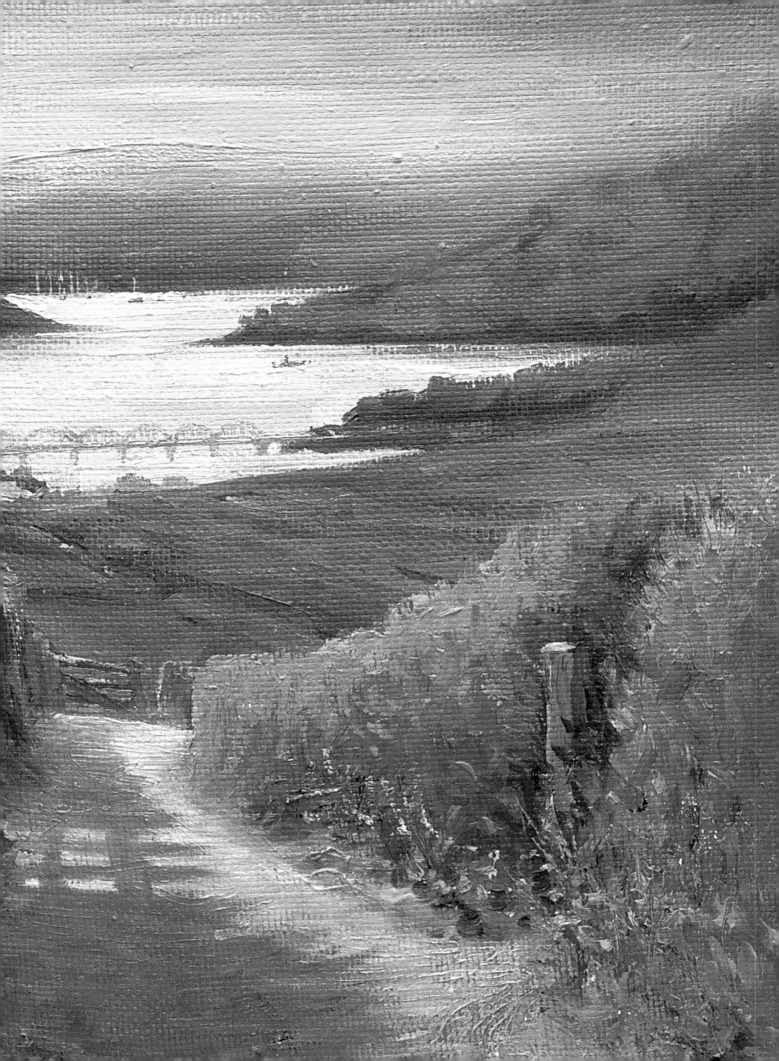

MATERIALS

PAINTS

Oil paints are made from pigment, which is ground to a fine powder then mixed with an oily binder and put in tubes. It is the binding medium that gives the paint its unique buttery feel and painterly character. Historically, binders were linseed, safflower or poppy oil. These days there are other mediums used as well, to alter the drying time or impart different characteristics. All oil paints dry by the oil hardening in contact with oxygen in the air, not by evaporation.

It is the use of these different binders that gives us the choice of product. We have three kinds of oil paint to choose from, and each kind has its own devotees.

The traditional oil paint has been around for centuries. It uses one of the binders that is quite slow drying, and there is a range of mediums that you can add to it.

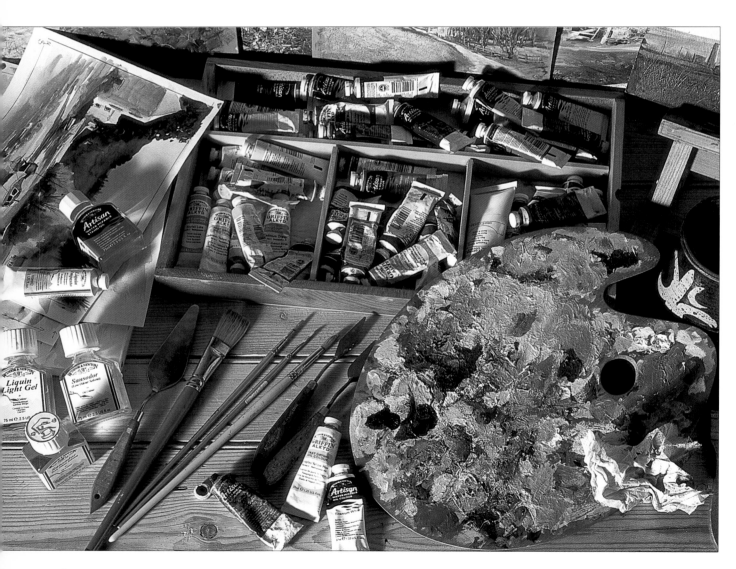

A selection of traditional, alkyd and water mixable oil paints.

Then there is the quick-drying oil paint known as alkyd, which dries in a couple of days, or sooner in warm conditions. The binder in this case is a synthetic resin.

Finally, we have the water compatible oil paint, which looks and behaves like a traditional oil, but which uses a water mixable linseed oil as a binder. There is a range of water mixable mediums available to add to it.

Which paint you choose depends on the kind of painting you intend doing, and on your personal preference. If you are happy working on a painting which is going to take several days to dry, and you have somewhere such as a studio where your work can remain undisturbed, traditional oils would suit you fine. If you have to work in the house or where others may complain about the smell, then consider a water mixable paint. Maybe you like the idea of travelling with your paints and want a quick-drying product, in which case alkyds may be the answer. I use all three, but I would advise against trying to mix one kind with another in the same painting.

Oil paints come in a wide variety of colours. In general, they fall into two quality categories: artists' quality, and students'. The difference is in the vibrancy – the artists' quality is more expensive, because it contains more pigment or takes more preparation. If you are using a colour that does not have to be bright, like a brown, then students' paint would be quite suitable. If, on the other hand, you want to paint strong, colourful flower studies, for instance, then some artists' quality paints would be useful. I would suggest getting the best paint you can afford.

MEDIUMS

A medium is a liquid which is added to the paint to make it more workable, while maintaining the paint's oily nature. There is a bewildering choice available, but the good news is that you need only have one or two.

The most widely used medium for traditional oil paint is linseed, which is used both as a binder in the paint and as an ingredient in oil paint mediums. Linseed comes in various forms such as cold pressed, which is fairly runny, and stand oil, which is quite thick.

All paint manufacturers produce a range of painting mediums that have particular properties, such as quick drying or glossy. I recommend starting with a couple at most: a bottle of linseed-based oil painting medium for general use, and a bottle of quick-drying medium such as Liquin, an alkyd gel which can also be used for a technique known as glazing.

The only time a medium is really essential is when you are working on an oil painting which has been allowed to dry. Then, subsequent layers need to contain a little medium to ensure good adhesion between coats. This is one of the few rules in oil painting and is usually known as 'fat over lean'.

It's perfectly practical to use paint straight out of the tube without using any mediums at all, which simplifies everything, as long as you continue working wet in wet (see pages 28–29).

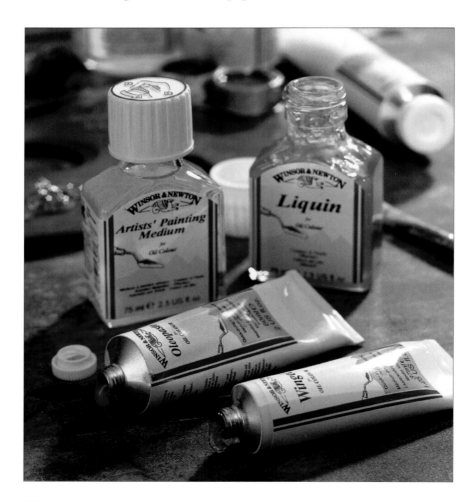

A selection of mediums available to oil painters. You need only one or two to begin painting.

SOLVENTS

Sometimes called a diluent, a solvent is used for diluting the paint, usually in the early stages of a painting, adding to mediums to modify their viscosity, and cleaning brushes and other tools. This is where the smell usually associated with oil paint comes from. The thing to remember about solvents is that they evaporate into the air you breathe, so care must be taken to ensure good ventilation if you are working or cleaning up indoors.

The traditional solvent is turpentine or 'turps'. This is distilled from a resinous product of pine trees, and is fairly pungent. The one most suited to artists is known as distilled turpentine. It is quite difficult to keep, as it yellows in daylight so should be stored in a dark place, and thickens in contact with air. For those who dislike turps, or have an allergy to it, there is oil of spike lavender, which, as its name suggests, has a pleasant smell, but is slower to evaporate than turps and more expensive.

Nowadays there are some excellent low odour thinners for oil paints, and they make an ideal substitute for turpentine.

The cheapest, and most widely available diluent is white spirit, sometimes known as mineral spirit. This is perfectly suited to cleaning up after a painting session, and many artists, myself included, use it for thinning the paint as well. For ease of use and affordability, I recommend white spirit or, if the odour is a problem, low odour thinners.

If you have an allergy to any of these solvents, then I recommend using water mixable oil paints since the only solvent required then is water.

Tip

If you are working indoors while using solvents, make sure you have adequate ventilation. Even low odour thinners are not healthy if you breathe in too much vapour. It is also best not to smoke when using solvents.

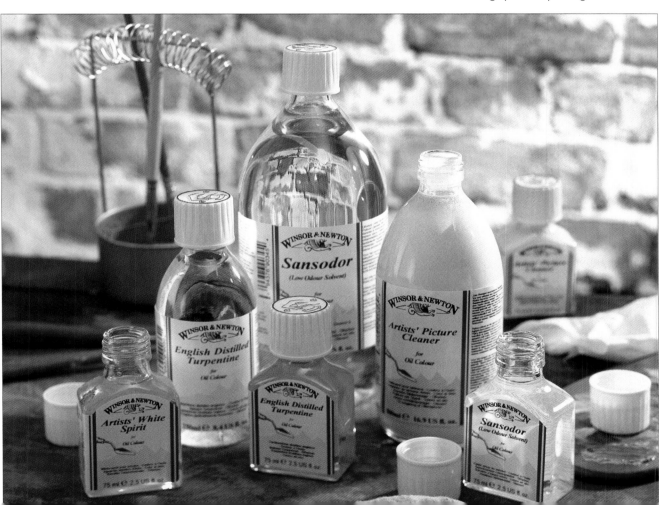

Solvents for thinning oil paints and for cleaning up after a painting session.

BRUSHES AND KNIVES

Brushes for oil painting are stiff, long handled tools that come in a variety of shapes and sizes. To start with, you can make do with three or four, and add to these as you gain experience. Avoid the very cheap sets that you see for sale in market stalls or discount shops; they are invariably poorly made and will not last long. The brush is your primary contact with the art work – it needs to feel comfortable in your hand so that you develop confidence in it. The best way to choose is to go to an art shop and look at a mid-priced range of brushes. Ask to see oil painting brushes, not general purpose or watercolour ones. The bristles are made of hog or synthetic bristle. I prefer synthetic brushes, as they seem to last longer and keep their shape better.

All brushes have numbers – the higher the number, the bigger the brush. The size of brush you choose is going to depend largely on what size of painting you intend to paint. In general, you will be using quite large ones for the initial stages of the work, with medium and small brushes used towards the end, for detailing.

The shape of brush is going to influence your painting quite a lot – the brush stroke is the building block of oil painting. There are four main shapes available: short flat, long flat, round, and filbert. The names are self explanatory, with the exception of the filbert, which starts out as a flat brush, then tapers towards the tip. My recommendation is a large long flat, size 8 or 10 and a long flat, size 2; a medium long flat, size 6; a filbert, size 4 or 6; a small short flat, size 2 and a small round, size 2. This small set will give you a wide range of marks and is quite versatile.

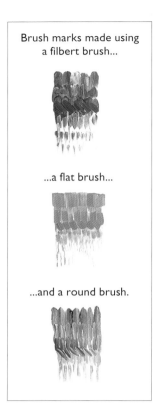

Brush marks made using a filbert brush...

...a flat brush...

...and a round brush.

My selection of oil painting brushes. You can start with three or four, and collect more as you gain experience.

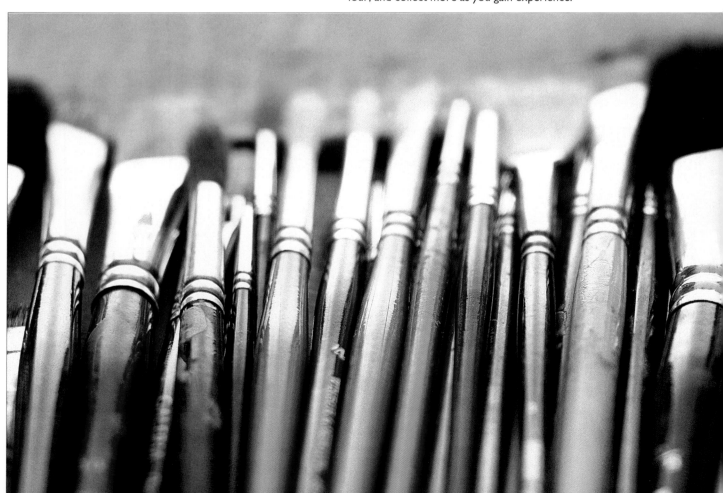

There are some additional brushes, with specialised uses, which you may find helpful as you progress. The most useful of these is a fan blender, for softening and blending edges and brush strokes.

Knives are useful for mixing, applying or scraping paint. As with brushes, avoid the very cheap sets that seem a bargain – they are unlikely to last very long. The major manufacturers all make a range of good knives that will give years of service. I'm still using a knife that I purchased thirty years ago.

There are two kinds of knife: painting knives, with a bend between the blade and the handle, and palette knives, where the blade comes straight out. The most useful type is the painting knife, which can be used for almost everything. You can make do with just one medium-sized one, but if you would like to try knife painting, a range of two or three different shapes would be useful. My favourites are the leaf-shaped ones that taper to a point, and I like to have a small, medium and large available when painting.

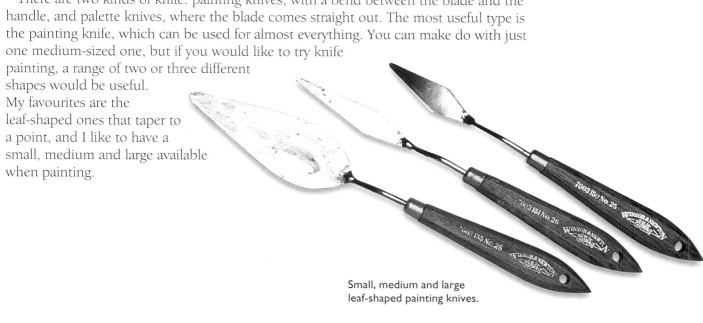

Small, medium and large leaf-shaped painting knives.

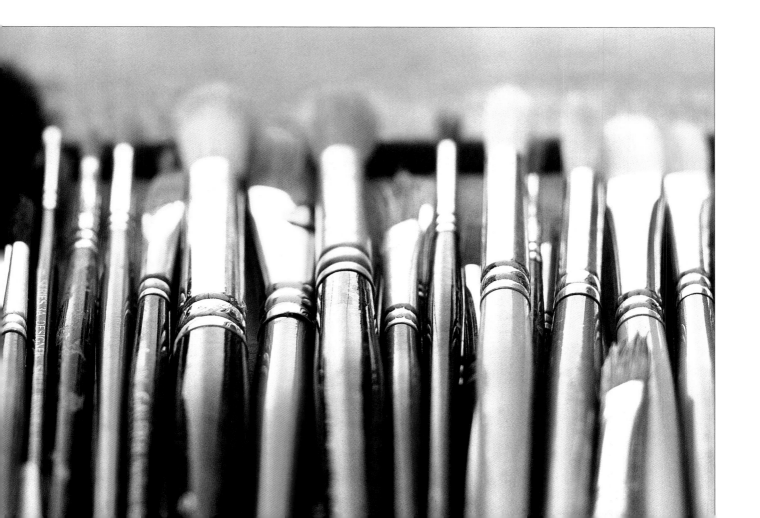

SUPPORTS

The marvellous thing about oil paint is that you can paint on almost any non-shiny surface, provided it is prepared correctly and primed with a good primer.

Traditionally, however, the surface or 'support' has tended to be canvas. This comes in two main types: linen, the best and most expensive, with an even and blemish-free surface that is delightful to work on, and cotton, a good, inexpensive alternative that stretches nicely and has an attractive, irregular surface. Both materials come in fine, medium and coarse finish, unprimed or primed. Portraitists and those needing a high degree of detailing often choose a fine surface.

Canvas is light, flexible, strong and pleasant to work on. Most art shops stock a range of pre-stretched canvases, already primed and ready for action. These come in a wide range of sizes, fixed to a wooden frame with staples or upholstery pins. The frame can be expanded when required by tapping little wedges into the corners behind the painting. This is necessary because the canvas sags slightly as paint is applied and will need re-stretching.

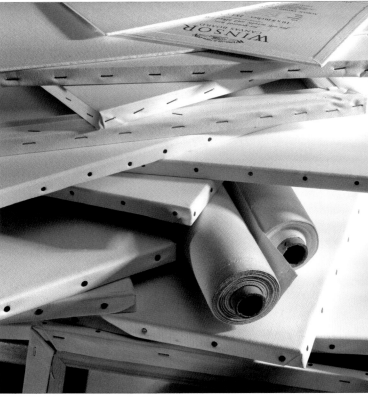

Useful supports include canvas on a roll, stretched canvas and canvas boards, as well as hardboard and cardboard.

Most artists choose to buy their canvases ready-made like this, to save time. If finances are a consideration, however, it is possible to buy canvas on a roll and the wooden 'stretcher pieces', and make your own (see the instructions opposite). You will need a large, flat working surface, a staple gun like those used by upholsterers, special pliers to tension the fabric while the staples are applied, and a lightweight hammer to tap home the wedges. If you are using 'raw' unprimed canvas, a couple of coats of primer will be needed to prepare it for use. I prefer acrylic primer, known as gesso.

Canvas boards are also available, consisting of a piece of canvas bonded to a stiff cardboard backing. These are available in a wide range of sizes and are very popular. They can be trimmed to fit odd-sized frames.

One of the most widely available supports is hardboard. This has a smooth side and a machine-textured reverse. The best way to use it is by lightly sanding the smooth side and applying a couple of coats of gesso. Other boards such as MDF and thick cardboard can also be used. For a more textured finish, try adding about twenty-five percent of acrylic 'texture paste' to the gesso and using an old household paintbrush to impart a visible brushstroke.

An advantage of using gesso is that it can be tinted with acrylic paint to give you a coloured surface on which to start painting. This is known as a coloured ground, and is a very useful way to begin. I almost always use a coloured ground – it makes judging tones and colours much easier.

Choosing a support is a matter of personal taste and experimentation. If you want to work out of doors, canvas boards are very useful, as they are light and rigid. You may feel it is more satisfying to prepare your own boards, or make your own canvases. Whatever you choose, provided the surface is primed correctly, you can rest assured that your masterpieces will last for many years.

Applying a tint to create a coloured ground.

Stretching canvas

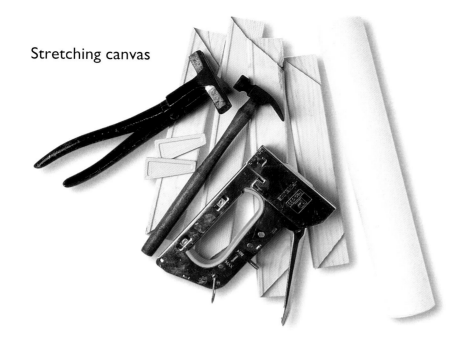

Stretcher pieces with wedges, pliers, a lightweight hammer, a staple gun and a roll of canvas, all used for stretching your own canvas.

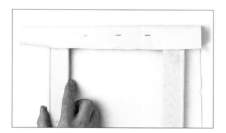

1. Assemble the stretcher pieces. Cut a rectangle of canvas about 10cm (4in) bigger all round than the assembled pieces, and place it face down on a flat surface. Place the stretcher pieces on top, with the chamfered, or sloping, edge of the stretchers against the back of the canvas. Using staples or tacks every 5cm (2in), attach the canvas to one of the stretchers.

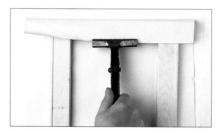

2. Grip the opposite edge of the canvas with the pliers and tension it against the opposite stretcher piece. While holding the canvas taut, put in a couple of staples near the centre of the stretcher to hold everything in place, then put the other staples in. Continue with the other two sides in the same way. Avoid stapling across the corners, as these will need to spread slightly when you tap in the wedges.

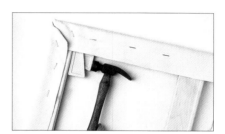

3. Fit the wedges into their slots, the ones near the canvas first, using finger pressure to start with. Then tap lightly with a small hammer, working diagonally from corner to corner. Do not be tempted to over-tighten at this stage. Repeat the process for the outer set of wedges. Finally, using a gentle tapping motion, work carefully around the canvas, corner to corner, to achieve the desired tension.

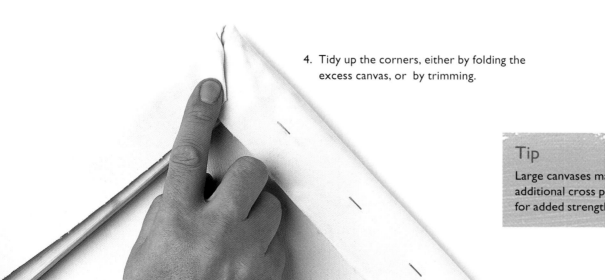

4. Tidy up the corners, either by folding the excess canvas, or by trimming.

Tip
Large canvases may need additional cross pieces, or bars, for added strength.

PALETTES

Palettes are traditionally wooden, kidney shaped, with a hole for putting your thumb through. There are similar styles in plastic and even glass. The purpose of any palette is to hold the paint, and give you enough space to manipulate and mix the colours, so choose as big a palette as you can comfortably hold – the more space you have for mixing, the better. Avoid the palettes with recesses that watercolourists use, as they are too fiddly, small, and difficult to clean.

It is possible to use trays, plates or foil dishes as palettes, and even sheets of greaseproof paper. The important thing is that they must be impervious to the paint, at least in the short term, and big enough for you to mix on.

I find disposable paper palettes quite useful; they are shaped like palettes, complete with thumb hole, and can simply be thrown away when finished with.

A very useful addition to any palette is a couple of dippers. These are little metal pots that clip on to the edge, to hold oil or solvent.

EASELS

Manufacturers make easels from a wide range of materials: alloy, wood, steel, even plastic. All have the same purpose: to hold your work securely in one position.

Whether you paint indoors or out, you will need to prop your painting up while you work. If you are unlikely to paint outside, a table-top easel will do. If you think you may like to venture out, or would prefer to work standing, a lightweight sketching easel is ideal. There is a whole range of box easels available, with drawer space to store paints and brushes. Then there are the large, solid studio types. Massive and heavy, these are almost pieces of furniture, and very stable. Whatever you choose, the main thing is to be comfortable while you work.

Position your painting at eye level, almost vertical, to avoid back strain. The easel you choose should have as wide a range of adjustment as possible, to ensure that you find the optimum position for comfort.

Tip

Experiment with different sitting positions until you find your most comfortable arrangement. Working hunched over, with the easel set too low, is a very common cause of an aching back and neck.

Table-top easels come in a wide variety of types, from the light aluminium kind to the traditional wooden ones. Lightweight sketching easels with telescopic legs are very portable and robust.

OTHER EQUIPMENT

Apart from the obvious artistic requirements, there are several items that you should have to hand in order to make oil painting easier and less messy. The most important is clean rags or kitchen paper, to enable the odd spillage to be contained and to wipe surplus paint off tools and fingers. Clean, lint-free rags can also be used to remove areas of paint from a painting, both to correct mistakes, and as a technique. Keep a carrier bag nearby for holding your dirty rags or kitchen paper.

You will find old screw-top jam jars useful for keeping solvents in.

A selection of sponges, both synthetic and natural, will come in handy for applying paint in a textural manner.

Cocktail sticks or wooden skewers are useful for incising into wet paint.

Good quality sketchpads plus a few pencils will enable you to compose your paintings and jot down ideas.

I always have a roll of masking tape to stop things flapping about, or to fix a photograph or sketch where you can see it.

Carrying wet paintings can be a problem, so I have a collection of shallow, rectangular cardboard boxes. I use masking tape to attach a wet painting into the base, and another in the lid. Then, when the lid is shut, I simply secure the box with a large elastic band. Bookshops or art shops often have boxes like this that they throw out.

VARNISHES

Whether you varnish your work or not is a matter of personal taste. A painting that is varnished is easier to clean, and the old varnish can be removed if it becomes dirty with atmospheric pollution over the years, and a new coat applied. Varnish can also restore a painting to the 'freshly painted' look, enhancing the brightness of the colours.

Having said that, some artists find the glossy look difficult to light, as reflections can be a problem. If you want to varnish your paintings, you need to be patient; at least four months, preferably longer, should be allowed before application. If you varnish too soon, it may bond to the paint layer and then, in the future, if someone wants to remove it, some of your painting may come off as well.

Some people use a product known as retouching varnish as a protection. It is very thin and can be applied almost as soon as the paint is dry.

I usually leave my work unvarnished and let the purchaser decide if they would like to have it varnished at a later date. On no account use anything other than an oil paint varnish from a reputable art materials manufacturer; household products may yellow and spoil your work. Never try acrylic or other varnishes on top of oils.

COLOUR

Of all the decisions that an artist makes, perhaps the most complex and personal is the choice of colour. Colour use is like a signature, as recognisable as a piece of handwriting.

Let us take a brief look at how colour works; how we perceive it. When we see a particular colour, we are seeing the reflected rays bounced off the coloured object to our eyes. All other colours are absorbed by the surface of the object. For instance, if we are looking at a red ball in daylight, all colours of the rainbow, present in white light, are striking the ball's surface, but only the red is reflected back to us. This red colour will have a different wavelength from the others.

An important factor when considering any colour is the kind of light falling on it at the time. Any change in ambient lighting will change our perception of all the colours. This all sounds very complicated, but don't worry, we are only going to be concerned with how to reproduce the range of colours necessary to create attractive paintings. The main thing to appreciate is that we are using paint to create an optical illusion – the illusion, on a flat surface, of depth and distance. To do this, we need to understand how colours work.

ADVANCING AND RECEDING COLOURS

The most important property of a colour, when considering the optical illusion of distance, is colour temperature. Colours are usually referred to as warm or cool, with red being considered a warm, advancing colour, and blue a cool, receding one. This means that reds tend to look nearer than blues. However, it is possible to get a coolish red when compared with other reds and the same is true of blue: you can get very cold or warmer versions.

Each colour will have a place on this temperature scale. Some, like greys and browns, may be difficult to categorise, and can be described as neutrals. Most people can see the difference between the temperature of red and blue, but it takes practice to see the difference between one blue and another, or spot a cool red.

It has long been accepted practice to include a warm and a cool version of each of the three primary colours: yellow, red and blue, in a choice of colours. A small selection of colours like this is called a limited palette. It is a good idea, when learning to paint in any medium, to restrict yourself in this way – it makes you aware of the potential of each of your selected colours, instead of using the whole range available.

However, with careful choice, a surprisingly large range of colours can be mixed from just three. It is very good practice to experiment in this way, as it teaches you a lot about handling paint, as well as colour.

The bluish section from the painting on page 24 appears to recede, while the red section from the painting on pages 32–33 appears to advance.

I regularly paint using only the three colours shown in this triangle, plus white. The colours are: lemon yellow, permanent rose, and phthalo blue.

As you can see, a lovely range of warm violets can be mixed as well as some nice oranges and greens. These colours are termed 'secondary' colours, and you should practise mixing them, rather than buying them ready made. Mixed ones are usually more interesting.

COMPLEMENTARY COLOURS

If you take any two of the three primary colours, and mix them, you will arrive at a secondary colour. The third primary colour is termed the 'complementary'.

For instance, orange is a secondary colour made from red and yellow. Therefore, the one remaining primary colour, blue, is the complementary colour of orange. In the same way, red is the complementary of green (a mix of yellow and blue), and yellow is the complementary of violet (a mix of red and blue).

This fact has been used by artists for centuries, but perhaps the best exponents of this colour theory were the Impressionists. Monet, Pissarro, Renoir and the rest all used complementary colour composition to stunning effect.

To put it simply, if your painting is predominantly a green landscape, a touch of red, on a figure or roof for instance, will look good. Similarly, a blue seascape will be made more vibrant by the inclusion of an orange sail. A still life can be made much more interesting by a careful combination of objects to emphasise complementary colours.

The thing about complementaries is that, if mixed together, they will always produce a brown or grey. The colours produced in this way are usually subtle and interesting. This property can be used to very good effect if you have mixed a colour too bright, and want to subdue it. Adding a touch of a complementary to a bright colour will tone it down, without making it dull. Try mixing a tiny touch of blue into a bright orange, or a little green into a red. Experimenting in this way will teach you a lot about colour.

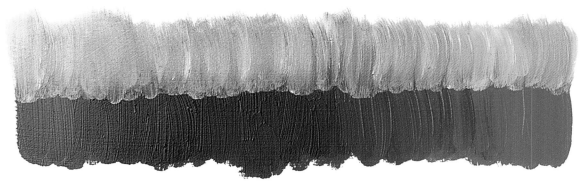

The complementaries, green and red, mixed to produce interesting browns, and the resulting colours mixed with white to create tints.

A LIMITED PALETTE

By far the most difficult decision faced by someone starting in oils is what colours to choose, so let's look at a basic range. I have used this selection of colours for many years, and find that there is rarely an occasion where I need more. The benefit of restricting yourself to a small set of colours like this – called a limited palette – is twofold. First, it teaches you a lot about colour by encouraging you to mix all the interesting shades, rather than squeezing them out of a newly bought tube. Secondly, it is much cheaper to get started! My choice of a limited palette includes a warm and cool example of each of the three primaries. There are three additional colours which I refer to as landscape colours, as they are most useful in that kind of painting. Finally, a white is essential.

The primary colours are shown below.

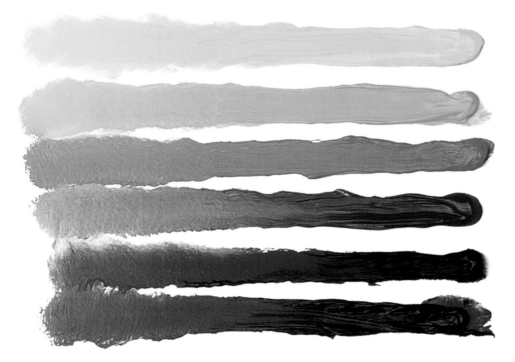

Lemon yellow: a bright, cold, semi-transparent yellow with a slight green tinge

Cadmium yellow deep: a dense, warm, darkish yellow with a hint of orange

Cadmium red light: a bright, strong, fiery warm red with a bias towards orange

Permanent rose: a cool, semi-transparent red, slightly violet with a hint of blue

French ultramarine: a warm, rich, dark blue with a touch of violet

Phthalo blue (pronounced 'thalo'): an exceptionally strong, dark, cold blue

The additional 'landscape' colours are:

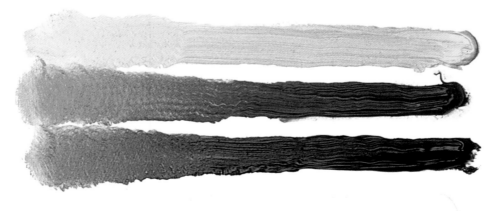

Naples yellow: a lovely, warm, dense, rich, sandy or buff cream colour

Burnt sienna: a warm, powerful brown with a touch of orange

Permanent sap green: a strong, dark, cool green that mixes well with other colours

Titanium white: a dense, opaque, cool white for lightening other colours

MAKING A COLOUR WHEEL

Making a colour wheel gives you valuable practice at mixing and applying paint, without the worry of producing a painting.

To make a colour wheel like the one shown, you will need the six 'primaries' plus white, and a medium-sized brush, plus a canvas board or piece of board about 30cm (12in) square primed with acrylic gesso. Draw around a small plate with an HB pencil to make a circle, leaving an equal space all round. Lay your colours out around the edge of the palette. Apply a postage stamp sized square of lemon yellow. Then paint an adjacent square with the same colour plus a touch of cadmium yellow deep. Mix your colour, a touch at a time, on the centre portion of your palette. To paint the next square, add a little more deep yellow until you end up after about four squares, with one that is neat cadmium yellow deep. Do not be tempted to thin the paint or spread it too thinly, as oil paint is a textural medium, so brush strokes and other marks are all part of it.

Working round from the deep yellow, add some cadmium red light. This must be a tiny amount, as it is quite strong. You will get a nice yellow/orange. Progressively add more, painting a square at a time, making a deeper orange, then orange/red, until you reach a square that contains pure cadmium red light.

Repeat this process with permanent rose. This will give you several dark reds, on the way to the square of pure permanent rose. This is a very dark and transparent-looking paint. In order to make it stand out, add a tiny amount of titanium white to it. At this point, it is a good idea to clean the palette and brush, ready for the violets, blues and greens. If at any time you get muddy-looking colours, it is because some colour has got where it should not be. This could be orange getting into the blue, red getting into the green, or maybe a tiny touch of yellow finding its way into the violet.

As you go, try to keep to the layout shown, so that the complementaries are opposite each other: yellow opposite violet, orange opposite blue, red opposite green. If your colours appear to have a big jump from one to another, simply scrape off the error and try again.

A tiny touch of French ultramarine added to the permanent rose will turn it slightly violet. It will also darken it, so a bit more white will be needed. Continue as before, increasing the amount of blue, plus a hint of white, until you arrive at a square which is pure French ultramarine. Add a touch of the very strong phthalo blue. This will change the character of the blue, from a warm violet blue to a cool one. You will need to add a little white to this as well.

Next, add a small amount of lemon yellow to give a nice turquoise blue/green. Add more yellow to arrive gradually at the greens, through to lime green, and back to yellow. If you wish, you can then paint a white ring around your wheel, and, using a clean brush, drag some of the paint out into the white to give a 'tint' of each colour, starting with yellow and working clockwise. If you do this, wipe your brush with some clean rag regularly to avoid the colours turning muddy.

By making a colour wheel like this, you will learn how to mix a large range of colours from a limited palette, get used to how the paint feels and end up with your own reference.

COLOURS AND THEIR SURROUNDINGS

Whenever a colour is placed beside another, there is an interaction between them. This is the basis of all art: how an image is changed and modified by its surroundings. We should be aware of these changes as we work.

A very common question that my students ask me is 'how can I make this look brighter?' Usually they are referring to a part of their painting that should stand out but doesn't. My answer is inevitably to do with the surrounding colour and its tonal value. A colour will always look brighter and more vibrant if is surrounded by a contrast. This can be tonal – darker or lighter – or a colour contrast. For maximum effect it could be both.

Look at these little squares of yellow and red. One pair is surrounded by a mid-toned buff colour. This isn't working with the colours in the little squares; it doesn't enhance them in any way. The other pair is surrounded by a colour that contains some of its complementary.

The yellow appears more vibrant because of the surrounding violet/grey, the red looks brighter because of the hint of green in the surround.

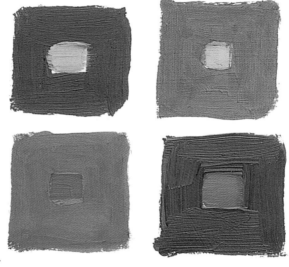

A colour looks brighter and more vibrant if surrounded by a darker 'neutral' that contains its complementary.

Colours can look warmer or colder, depending on the adjacent colour.

These two squares both contain an identical grey square. The one in the brown square looks darker and cooler and the one in the blue square looks paler and warmer. Yet they are the same colour!

In the same way, the surrounding colours can also look different, even though they may be the same.

Look at the two grey squares. They are exactly the same colour, yet appear different due to the brown and blue squares they contain.

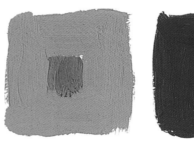

Colours are modified by their surroundings.

When planning a painting, think in terms of adjacent colours, especially where maximum impact is required. Be prepared to modify colours; something that looks just right on the palette may appear entirely different when placed in position on the painting. If it

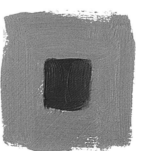

Colours modify their surroundings.

looks too bad, sometimes the only solution is to scrape the wrong colour off and try again. That is the beauty of oils: their flexibility.

INTERESTING NEUTRALS

With such a wonderful range of vibrant colours to play with, the 'dull uninteresting' greys and browns can get a little overlooked. Too often, the grey is just squeezed out of a tube, or mixed from black and white to give a boring, uniform colour that contributes nothing to the work.

Mixing neutrals should be part of every artist's repertoire; not only will you learn more about colour, you will be able to paint surroundings that really make your brighter areas work.

So, what is meant by a neutral colour?

Basically, any colour that is fairly dull, and harmonises well with other colours, can be described as neutral. Neutrals can have a bias towards a primary or secondary colour, for instance, green/grey, pink or violet/grey are basically grey, but with a hint of the other colour.

There are many ways of producing good neutrals: often they are the product of mixing two complementaries together. Here are a few of my personal favourites.

Naples yellow and French ultramarine. This is a nice way of producing a range of warm or cool soft greys. Since Naples yellow is so pale, there is no need for additional white.

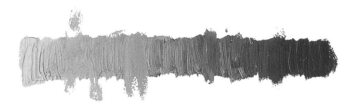

Permanent rose, sap green and white. This goes from a pinky grey through to a grey/green. White is needed to make the mix paler, otherwise this combination looks black.

Cadmium red light, phthalo blue and white. This unlikely mixture gives a range of purple/greys that are almost brown.

Burnt sienna, French ultramarine and white. This is one of my favourite mixes for grey. Very dependable, the resultant grey can take the addition of other colours to create a whole range of grey/greens, grey/pinks, etc.

USING COLOUR TO CREATE AN ILLUSION

All art has an element of illusion about it, from painting a look of dappled sunlight on a flat canvas, to making a piece of marble look like a human being. As artists, we are in the illusion business!

One of the most common illusions we have to perform is creating the impression of distance, as in a landscape, on a flat surface – the canvas.

The simplest way of doing this is known as aerial perspective, and it is quite easy to master, once you have grasped the idea of warm colours advancing and cool colours receding. If you look at distant hills or mountains, they will appear to have a blue tinge. We accept the fact and quite often don't even notice. Even trees, which we know are green, can look nearer to blue if they are far away. They also look paler and less distinct. So, if we make our distance pale, with a hint of blue, it will tend to look far away. Conversely, if we make the nearest part of our painting, the foreground, warmer, sharper and with more contrast, it will tend to look nearer.

The bits in between, the middle distance, will work best if they get progressively warmer as they get nearer.

Here is an example of aerial perspective in practice.

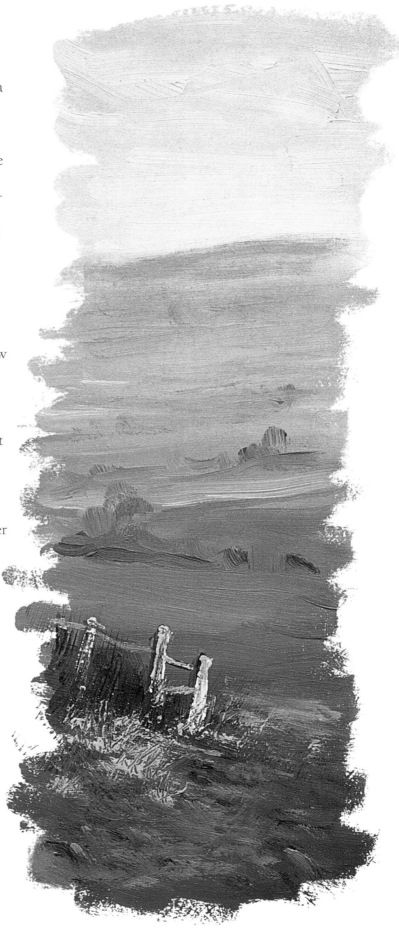

The sky

This is warmer at the top than near the horizon, so the upper part is painted with a mix of titanium white with a little French ultramarine. Gradually moving down the sky, a little more white is added to this mix, together with a tiny touch of phthalo blue. Near the horizon, the sky is comprised only of white and a touch of phthalo blue. This will give perspective to the sky, making it appear to recede.

Skies can be any colour, not just blue. They can be grey, pink, violet, almost any colour except bright green. As long as you paint them cooler and paler as they near the horizon, they will look right.

The distance

This is best considered as being kind of pale blue, with no more than a hint of other colours. The distant landscape must not be painted too dark, otherwise it will not look far enough away. I often use ultramarine with a tiny touch of Naples yellow to grey it slightly. Plenty of titanium white needs to be used in the mix, to ensure the horizon is pale enough. It should be a little darker than the sky, but not much. The most important thing is to avoid any real contrast in this area.

The middle distance

In this area, our colours can be warmed very slightly. A touch of lemon yellow, added to the 'distant' colour, will give a nice, cool blue/green without losing the receding quality, so that it will still look far away. As you work towards the near part of the middle distance, a warmer green can be made, using a little of the warm yellow, cadmium yellow deep, in the mix. Darker details, such as hedges and trees, need to maintain a blue bias, so they stay in the background. We do not want too much contrast in this area either, so things must not get too dark.

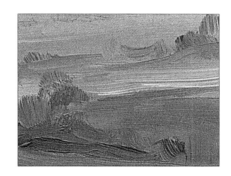

The foreground

The greens in this area are warmer and slightly darker. Sap green, lightened with titanium white and maybe a touch of Naples yellow, will be warm enough to start with. Here and there a little burnt sienna is useful to warm the green still further.

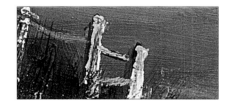

The immediate foreground

In the immediate foreground, some extra contrast is provided and the bottom of the image is the warmest part of all. There are even some tiny touches of red among the areas of burnt sienna.

TECHNIQUES

Of all the materials available to today's artist, oil paint has to be the most versatile. As long as the surface is prepared and primed correctly, it can be applied in almost any way, by almost any method.

Over the six hundred years or so that oil paint has been available, working practices have developed to ensure the durability of the art created with it.

The techniques of oil painting fall into two categories: first wet in wet, when the painting is completed more or less in one go and wet paint is applied on wet paint, usually within a day or two. Secondly, wet on dry, when the painting is allowed to dry thoroughly between coats, with many days or weeks between layers.

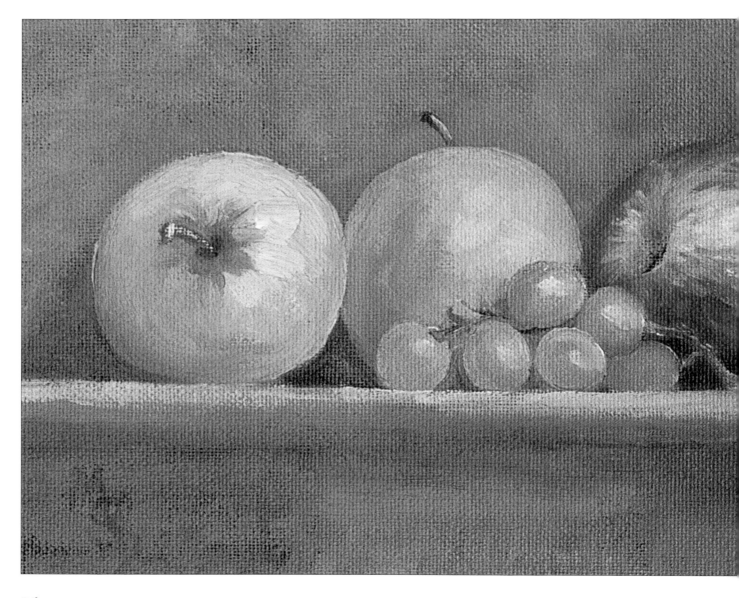

Still Life With Apples and Grapes

400 x 200mm (15¾ x 7⅞in)

This painting uses most of the traditional oil painting techniques.

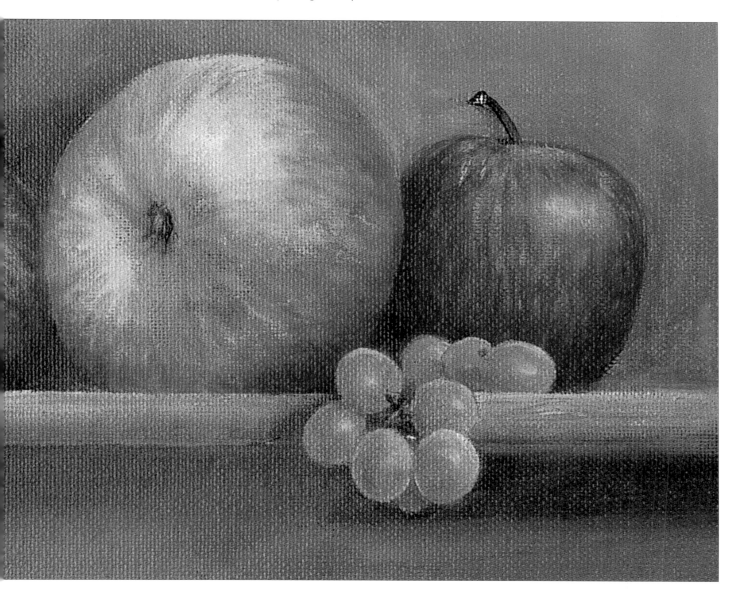

WET IN WET

This is the easiest technique to start with. There is no need for mediums, the painting proceeds relatively quickly and any corrections can be made by simply scraping off. The only drawback with a wet in wet technique is that every time your brush touches the painting, a little of the paint that was previously applied comes off on it, so you could get an inadvertent mixing of colours. This is easily remedied, however, by wiping the brush periodically with some clean rag.

Alla prima

This is not for the fainthearted! It is a direct method of painting, much favoured by many of the Impressionists. There is effectively only one layer of paint applied, with each single brush stroke standing alone, and with virtually no blending or softening. The idea is to impart an impression of spontaneity and fluency. It is possible with this method to scrape or wipe off areas that do not work, and repaint them, but the aim should be to get the image directly on to the canvas in one go. It takes a lot of practice!

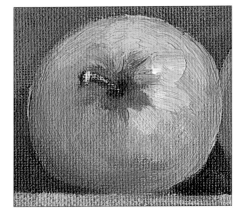

This apple was painted using alla prima, the most direct wet in wet method, with no attempt to blend or hide brush marks.

Impasto

This is a method of applying paint that uses its rich, buttery quality to good effect. The idea is to impart a texture by the brush strokes remaining visible. Paint should be applied thickly, with minimum overworking. Because of the heavy texture, impasto will often appear to 'come out' of the painting, so care must be taken not to use it to excess in the distance, or your work will not appear to recede. Aim to make the brush strokes follow the form of the object you are painting, for maximum impact.

Blocking in, then overpainting

The painting is started by putting in simple areas of flat colour, with no detail. Often this is done with a large brush and paint that is slightly thinned with solvent. It is a traditional way of starting, and is very versatile. Whole areas can be moved about or changed very quickly. The blocking in can be in tone only (monochrome), vibrant in colour, or realistic. When the whole of the canvas has some paint on, it can then be reworked with more detail, using smaller brushes. As the underpainting is still wet, it helps to wipe the brush on some clean rag from time to time to avoid creating muddy colours.

This part of the painting was blocked in, then overpainted. The flat areas were done first, then form was implied by subtle tonal changes using dark and light greens.

Scumbling

Scumbling is a traditional painting technique which imparts a lively, textured look. It relies on a 'loose' brush stroke, where the colour underneath shows through here and there. The underlying colour can be a complementary of the scumble, it can be tonally different, or quite vibrant. The main thing is to impart a loose, spontaneous brush stroke, with plenty of little gaps to let the colour underneath show. The benefit of this technique is that it tends to unify the painting, or pull it together, in a very attractive way.

This part of the same painting was scumbled loosely over a wet underpainting of yellow. The brush strokes follow the form of the apple.

Blending

One of the main characteristics of oil paint is that it lends itself well to being blended. It is possible, with care, to remove any visible signs of brush stroke, so that the colours and tones merge imperceptibly into one another. There are certain subjects, and certain areas of a painting, where this is quite useful: such as a clear blue sky where a seamless change from a warm to a cool blue is required. The best tool to use for blending is a fan blender brush, used lightly, first diagonally across the edge to be blended, then along it. Wiping the brush regularly with some clean, dry cloth helps. Softer brushes make less of a mark.

The gradation from light to shade here has been carefully blended using a fan blender brush.

Sgraffito

Working wet in wet can make it difficult to paint crisp, clean lines. Because of the nature of the paint, lines applied by brush tend to be fairly thick, however small the brush. One way to achieve controlled, thin lines is by sgraffito. This simply entails scratching back through a wet layer of paint to show the colour beneath. Various tools can be used to do this, from knitting needles to sharpened twigs. I always keep a couple of brushes with sharpened handles specially for the job. The technique works best where there is a good tonal contrast between the layer being scraped through and the colour underneath.

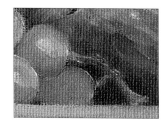

The sgraffito technique was used to scrape paint away in the area of the grape stalk.

Knife painting

Some artists specialise in working solely with painting knives, without using brushes at all. Others will use a knife for certain touches, where the particular chunky, knifed look is required. One advantage is that knives are easier to clean than brushes – no solvents are required, just some clean rag. A painting knife can be used to scrape back large areas quickly, both as a correction and a technique in its own right. When painting with a knife, it is usual to use undiluted paint throughout the painting. It is worth experimenting with different shapes of knife, and even using home-made 'blades' made from pieces of plastic or thin ply.

Here, a painting knife is being used to scrape back the paint to create the shape of a farmhouse.

Lifting out

When working on a painting that has lighter images surrounded by a darker background, it can be useful to apply the background first, then, using a piece of rag, wipe out the required shapes of the light areas. An advantage is that the application of the bright parts will not be contaminated by the colour beneath. When using this method, keep rotating the rag or paper so as to use a clean piece each time, otherwise you will end up wiping the paint back on. Sometimes a tiny touch of solvent on the rag or paper will help to remove the paint. Lifting out works best if the board or canvas is a light colour to start with.

Lifting out paint using kitchen paper dampened with solvent.

This is the left-hand section of the painting on pages 26–27, and this part was all painted using wet in wet techniques as detailed above. These techniques are the most direct and immediate method of working, but for some people it is impractical to finish a painting in one go – there may not be time. For others, the slower, more methodical way of working associated with wet on dry techniques (see pages 30–31), where the painting takes shape over several sessions, suits their temperament. The great thing is, both ways of working can produce successful results. There is no right or wrong way.

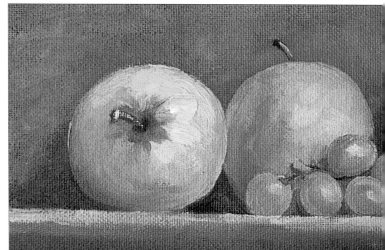

WET ON DRY

All of these wet on dry methods can be carried out using opaque or transparent layers, applied thinly or more thickly. The most important thing in the wet on dry methods is to let the painting dry thoroughly before attempting any further work.

There is an important rule that applies to every wet on dry technique. Put simply, any paint that is applied over a dry layer of oil paint should have more oil content than the previous one. Working wet on dry, begin a painting by thinning your paint with turps or white spirit, then, when dry, work on it with paint that has a little linseed oil or painting medium added. You do not need to add much; just a touch will do. Paint straight out of the tube will also be suitable, because it already contains enough oil. So, if you are working on an oil painting that has been allowed to dry, and your next layer needs to be diluted slightly, use a touch of oil or painting medium. The thing to avoid is thinning the paint, in the later stages, with any solvent. This rule is generally known as fat over lean, and if used, avoids the chance of poor adhesion as the paint dries.

Layering

This is the simplest of the wet on dry methods to get to grips with. In its simplest form it entails blocking in, then working back over the complete painting once the first layer is dry, usually in opaque paint. Changes can be made and details added as the image develops. At this stage, it can be left to dry again, then further adjustments or corrections can be made and more detailing carried out. The beauty of working in this very traditional way is that the painting can be set aside for weeks or even months, and then continued. If there is a drawback to this way of working it is that a painting may never get finished!

Scumbling

The same method as the wet in wet technique, when worked wet on dry, scumbling creates a crisper and more defined edge to the brush strokes. It is important to allow the colour underneath to show through, and to keep the brush marks lively and irregular.

Used wet on dry, smaller brushes can be used to add texture to areas that appear too 'flat' or uninteresting. Remember, if the paint needs diluting slightly, oil or medium must be used, not solvents.

Dry brush

This can only be done on a completely dry surface. If the underpainting is slightly tacky, it drags too much paint off the brush. To get the best results, the brush should contain just sufficient paint – if necessary, wipe some off with a rag. Then, holding the brush well back on the handle, and almost parallel to the canvas, it is allowed to make contact with the surface so the paint is literally dragged off the brush. The technique works best with very light paint dragged across a darker background.

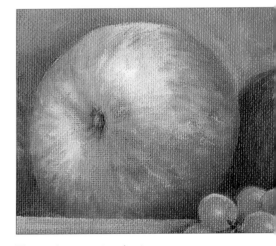

This apple was painted using a combination of scumbling and layering techniques, wet on dry. You can achieve more detail when working on a dry underpainting. Here, the original yellow/green colour is showing through in places. The shadow was carefully added when the painting was dry.

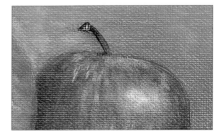

The shine on this apple was applied in white using a dry brush technique.

Glazing

Probably the most traditional and classical of all the wet on dry techniques, this has several variations, all similar in that they use a transparent layer of paint, rather than opaque. To make the paint transparent, it is mixed with a glazing medium. Some fast-drying mediums, such as alkyd mediums or gels can also be used; read the small print on the label to find out. A glaze can be applied to change colour or tone, without losing the form or texture beneath – it acts as a coloured varnish. Many artists use it to apply shadows and impart form. Alternatively, you can paint a monochrome, then apply the colours as glazes afterwards. Known as 'grisaille', this technique has the benefit of letting you concentrate on the tones to start with, leaving the colour decisions until later. Never try to use linseed oil or similar for glazing; it will not work and may spoil a good painting. Always use a glazing medium. Scumbling and layering can also be carried out using transparent glazes, instead of opaque paint, for a multilayered effect.

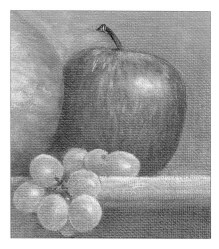

This apple was painted as a monochrome in tones of brown and cream. When dry, the russet red colour was glazed on. When the glazing was dry, the shine was applied in white using a dry brush technique.

This part of the painting, shown in full on pages 26–27, was done using wet on dry techniques.

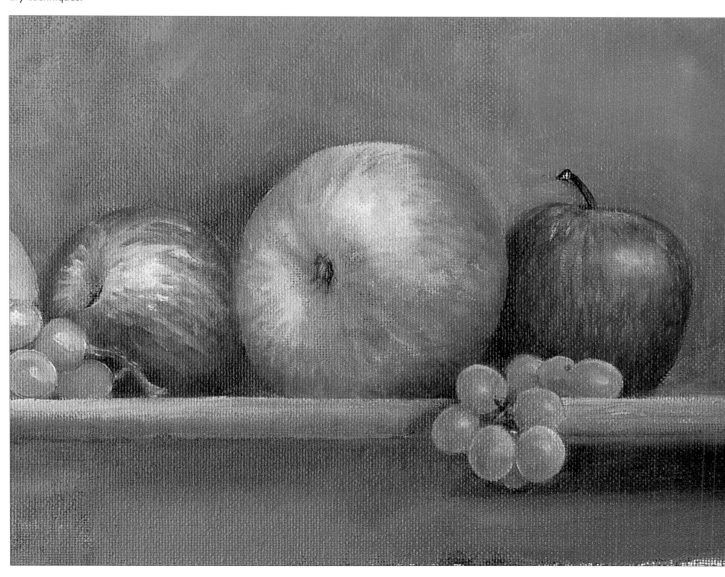

COMPOSITION

To a certain extent, fashion has dictated what is acceptable in a painting, both in content and technique. Nowadays, however, we are fortunate to be able to get away with almost anything! A painting will not look good, however, if it is poorly composed.

The process need not be complicated; all it really means is doing a bit of planning before you pick up a paintbrush. It is far easier to change components of an image at the drawing stage than to scrape off half a painting because it has not worked.

A painting is like a journey to somewhere unknown. We can set off, hoping for the best, and making decisions as we go along, or we can try to get some information about the journey in advance. In other words, we can trust to luck – or make a plan.

I think failing to plan is like planning to fail. The more errors we can eradicate before we set off on our artistic journey, the better. As we work, we will encounter unexpected problems, but these challenges are part of the joy of painting.

Colour should be chosen to impart mood and atmosphere, and to suit the type of composition: strong, vibrant colours are more suited to dynamic compositions, and softer colours to restful scenes.

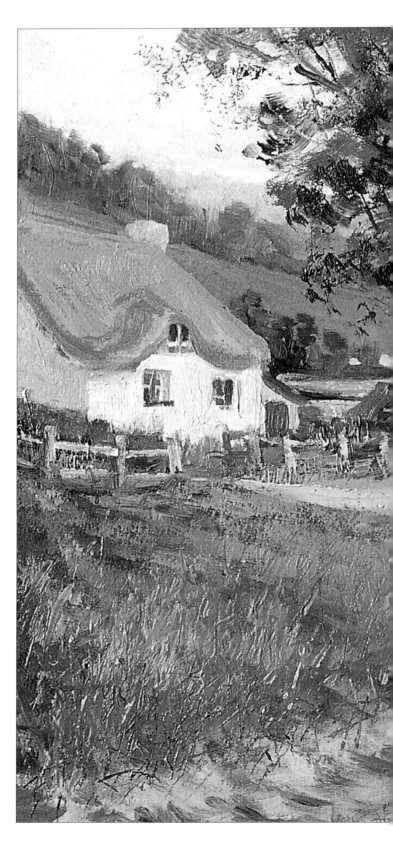

Poppies by the Path

407 x 305mm (16 x 12in)

The composition of this painting relies on warm colours in the foreground and cool colours glimpsed through the trees, to give the illusion of distance. The pathway leads the viewer's eye in a curve around to the cottage, where the orange colour on the shed roof attracts the eye to the fence, along to the open gate and trees. There is no attempt to 'squash' the trees into the picture, they are allowed to vanish out of the top.

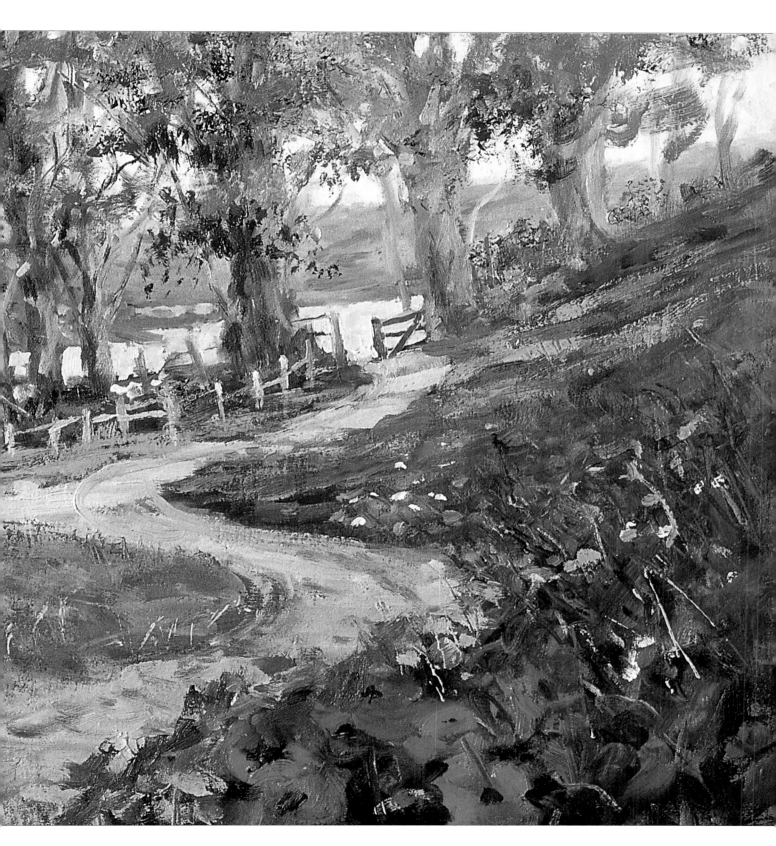

USING THUMBNAIL SKETCHES

The main planning tool for any artist, in any medium, is the thumbnail sketch. Thumbnail sketches are ideas made visible. They need to be small because they should be quick to do. They should be simple, because we don't want to waste time on complication if it may not work. We make little drawings, no bigger than a matchbox, to test our ideas. If they look good, we can continue. The ones that do not work, we simply discard. A small A5 sketchpad is invaluable for this kind of work. Sometimes, it is right first time, but usually I find I have to do three or four quick sketches to hone my ideas. All the paintings shown in this book started out as little matchbox-sized drawings. I cannot remember the last time I did a serious painting without some sketches first.

The main thing to consider when looking at the image you want to work from is, what can you leave out? Some artists call this 'distilling the scene'. How much can you lose, while still retaining the essence of the image? Is that lamp post really essential? Do those bushes have to be there? Paradoxically, the more you can dispense with, the better the painting will look! Leave out the nonessentials.

The next thing to ask yourself is, what is my painting going to be about? This will encourage you to consider if it has a clearly recognised subject. If the answer to the question is vague, such as 'a sunset' or 'a forest', you may encounter problems, unless you are very experienced. Always try to have a clear subject. It need not be a person or building – it does not have to be a solid object at all. For instance, instead of 'a sunset', you could make it a reflection of the setting sun on a lake. The reflection is the subject. Instead of a forest, the light catching a single tree becomes the subject. This is the focal point, which should attract the viewer's eye.

These sketches form the basis for the Fishermen project on pages 74–81. They were a means of simplifying the composition so that I knew where to place the various elements. They were also a way of jotting down visual ideas.

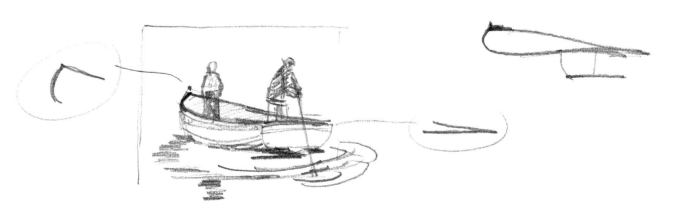

Having decided on what we can afford to leave out, and the focal point, we can start to make some plans. Where are we going to put our subject – the focal point – for maximum effect? This is the first major planning question. The first inclination for beginners is to place it right in the centre. This is something you must work hard to overcome. A subject placed exactly in the middle will look quite nice, until you finish the painting! A central focus will have very little impact and virtually no interest for the viewer. Some exceptional artists can get away with it occasionally, but for the rest of us the focal point should be elsewhere.

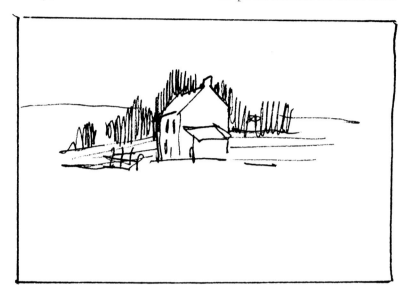

Avoid placing your focal point in the centre of the painting.

An easy way to get to grips with this problem is by using a simple grid. Divide the sketch into thirds, horizontally and vertically. Then, by avoiding having the focal point in the middle of the central square, you are well on the way to developing a sound composition. If you are working on a landscape, placing the horizon a third of the way up or down the image works well; with a townscape, putting a building a third of the way in on one side or the other can be very effective.

Working like this, with a grid, gives you a compositional guide. With practice you will be able to gauge where to put major features by eye, but to begin with, use a 'rule of thirds'.

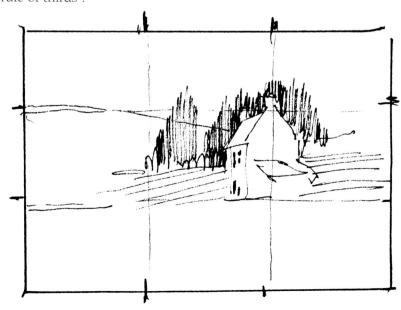

Draw a simple grid, dividing your sketch into thirds, horizontally and vertically.

The next question is, how do we lead the viewer's eye around the painting? When we look at a painting, our eyes travel around it, in a way that appears to be random, but is not. What happens is that we are subconsciously being encouraged, by line, changes in tone and colour, to move our eyes in a particular direction. The best works of art lead us around them just as a film director controls a movie: we look where the artist has planned.

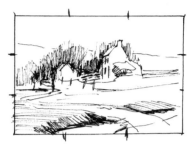

These sketches show how the eye moves around a composition, drawn by the use of line, tone and at a later stage, colour.

It is relatively simple to make this work in our paintings: it is about making connections visually. If you have an image with one element on one side and one on the other, the eye is disturbed by it – it wants to fluctuate between the two (see the sketch below, left). If one element is made more important than the other, and a link is provided for the eye to travel along, it works much better (see the sketch below, right).

With one element on one side and one on the other, the eye fluctuates between the two.

Here, one element is dominant and there are links between the two to lead the eye.

When we reduce paintings to lines, we are faced with a choice of three basic types of composition: static, dynamic or mixed. A static composition has lots of horizontal components and imparts a restful feeling. A dynamic composition has diagonals and feels full of movement and vibrancy. A mixed composition has elements of both of the above and can have both quiet and busy areas. These should complement each other, and be linked in some way.

Static composition

Dynamic composition

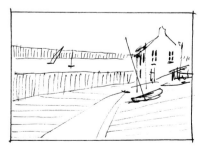

Mixed static and dynamic composition

USING PHOTOGRAPHS

The use of photographs for source material is a controversial topic among artists, and especially among art teachers. Some allow it and some regard it as cheating. There is no clear answer, except to say that many, if not most, professional illustrators use photographic reference, and so do many fine artists. Whether they admit it or not is a different matter!

Personally, I see nothing wrong with using photographs to start an image; that is, we as artists should take the image and change it sufficiently so that it becomes our own.

The way to do this is usually via a few thumbnail sketches, to work out what we want to put in or leave out. Never take a photograph and try to copy it exactly. We can almost always improve on it, especially in areas such as shadows and contrasts.

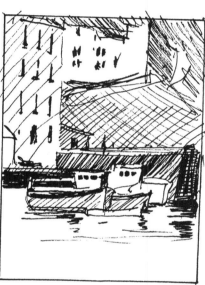

I recommend taking a photograph and seeing how many potential images you can make from it, as I have done here with this image of Polperro Harbour. As you can see, there are several possible paintings in it. Always make the sketches in tone as well as line, as that gives you more idea of how the painting may eventually turn out.

Don't be afraid to add elements, or leave things out to make the painting look better.

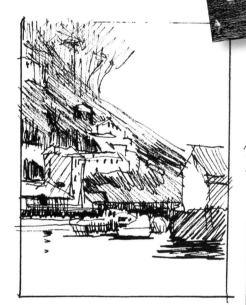

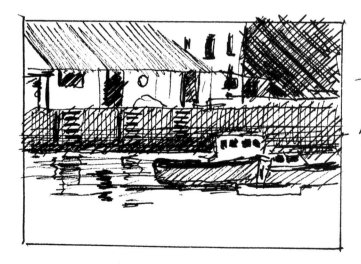

USING COLOUR IN COMPOSITION

Colour in composition should follow the same principles. If a painting has masses of diagonal lines running in all directions, but is painted in pastel shades, it could look strangely unbalanced. Conversely, if an image is predominately restful in design, but is painted in strong vibrant colours, it may look wrong. Whatever the subject, it is worth remembering that as artists, we make the choice of colours in our work. Colour imparts mood and atmosphere, so we decide on our colour scheme according to the mood we want our work to evoke in the viewer.

Turn of the Tide
305 x 254mm (12 x 10in)

This painting and the one on the next page were made literally yards apart from each other, in Plymouth's Barbican area. This is an evening scene, with yachts being taken out of the water on the distant slipway and sails coming down in the last half hour of daylight. I chose pink, with purple/grey and soft blue as the colours for the darker tones, and orange for the highlights on the water and near the skyline.

Bright Harbour

305 x 254mm (12 x 10in)

In complete contrast, this is a strong, vibrant image in which I wanted to capture the essence of the brightly coloured fishing boats with their jumble of sails and gear. If you look closely you will find that the shapes are deliberately distorted to add to the lively effect of the colours. Look at the two images again. Could you imagine them working if the colours were changed and the busy one was painted in subtle colours, and vice-versa?

TONE IN COMPOSITION

Of the three main elements of composition – line, colour and tone – it is tone that is so often overlooked by the beginner. It is also tone that is the most important. If you excuse the pun, it seems to be a grey area!

When we talk of tone, or tonal values, we are referring to the comparison of the relative darkness or lightness of one area with another.

The thing that causes the confusion is that tones are usually also colours. If we look at a mid-blue, for instance, then a mid-red, we see them as different. They are blue and red. Yet tonally, they may be the same. A mid-blue when compared to a yellow may be easier to see; the yellow will look lighter. Seeing tones accurately takes practice and concentration. It is well worth the effort, as every painting you make will work better if tonal values are considered right from the start.

To begin, ask yourself some questions:

How am I going to make my focal point stand out?

How can I avoid making the distance look too near?

What is the easiest way to make objects appear three-dimensional?

Where are the darkest and lightest areas of my painting going to be?

These are all tonal questions, and every painting you do will work better if you ask them. Every painting will need a different set of answers, so keep asking!

To understand how tone works, it can be useful to make a grey scale. This is simply a dark colour to which white is progressively added, to produce a strip ranging from very dark at one end, to white at the other. In this example, I have made a mid-dark grey from burnt sienna, French ultramarine and white. This has been lightened in clearly recognisable stages, to give seven tones, with a very pale grey at the lightest end.



Tip

To enable you to see tones easily, try squinting at the image through half-closed eyes. This exaggerates the contrast, making it easier to appreciate the difference in tone.



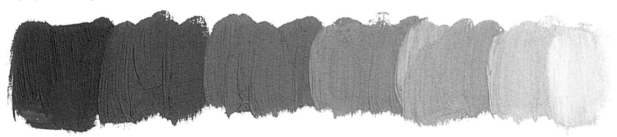

A good practical exercise, now we have the tones, is to put them into a painting. Paintings done in this way are called monochrome. In the example opposite I have produced a simple still life painting of a jug and apples using the seven tones. There is no black or white in this image, since these are best kept in reserve for the very darkest or lightest areas. If your image does not have extreme darks or lights, you probably will not need black or white.

When working in this way, the first thing to do is block in mid-tones. That is, those areas that are not the lightest or the darkest. On the grey scale strip, these are greys number three, four, and five. Go as far as you can with these three tones, then apply the next darkest, and the next lightest. Make any changes gradual, and keep looking at the adjacent area as you paint: remember, tone is about comparing. If part of the work suddenly appears to stand out too much, it means you have too much contrast in that area. Scrape it off and try again, if necessary. Next, put in the darkest area that you have, then, last of all, the little touches of highlights.

This is a very useful exercise. It teaches you how to see and paint tonal values.

If you wish, when the image is dry, you can work over it in colour, either solid, opaque colour that is similar in tone to the areas underneath, or you could use coloured glazes, allowing the shapes and textures of the original brush strokes to show through.

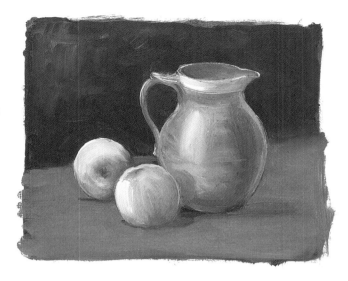

It is best to plan your tones right from the beginning, using little sketches to help you. Remember, always have an idea of what your focal point is and where you are going to put it. Then you can reinforce its importance by making it stand out, tonally, from the surroundings. That is why your thumbnails should contain as much tonal detail as possible.

Look at the sketches below, for a painting shown on pages 56–57. Which one gives you the most information?

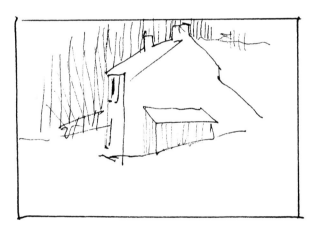

This sketch shows the shape of things and not much else.

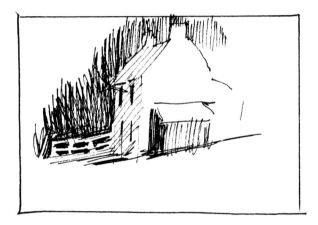

This, however, is much more helpful. It shows how the painting of the farmhouse can be made to stand out by darkening the background.

Here is the idea from the sketch, translated into colour as well as tone. As you can see, the building stands out well.

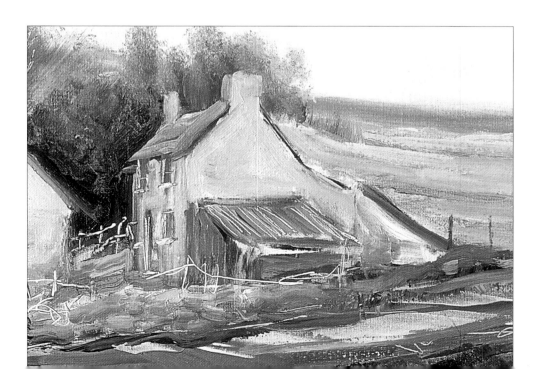

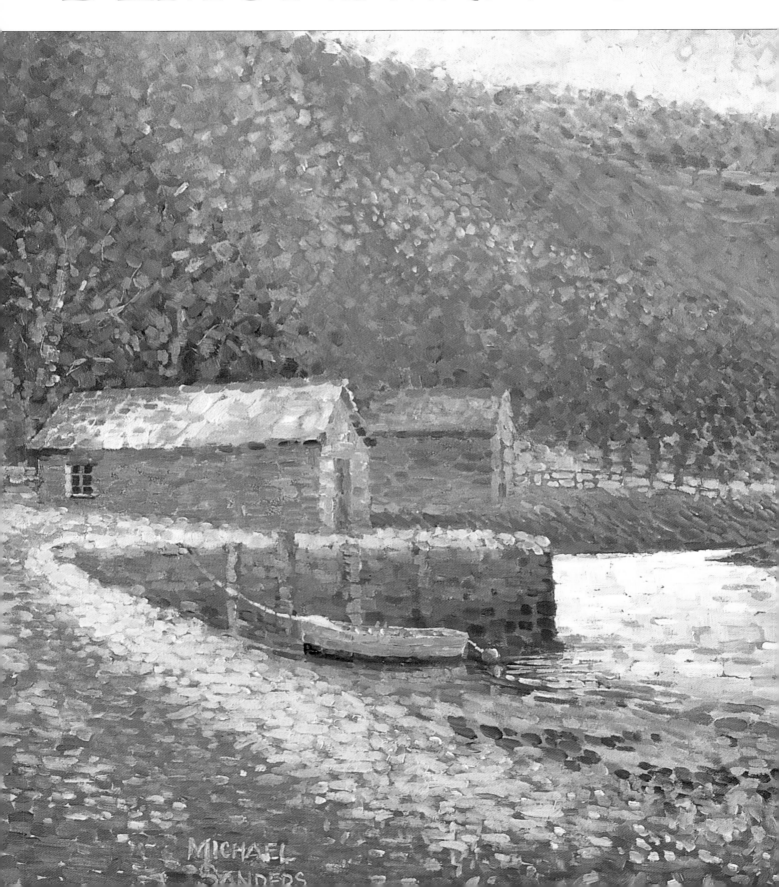

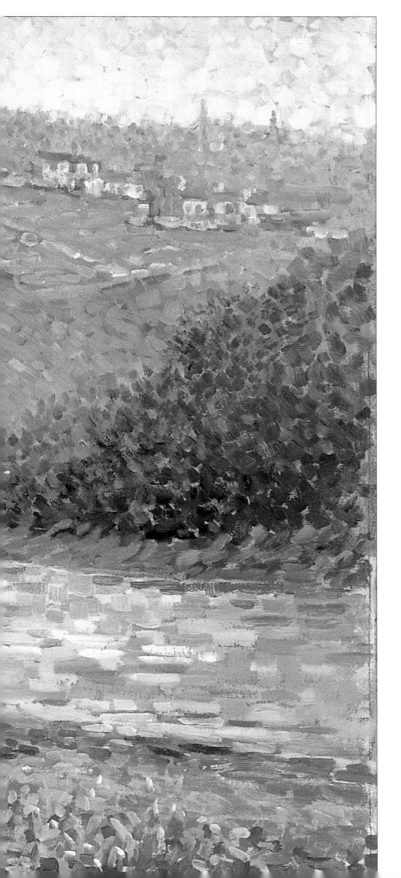

I hope you have been following the suggestions so far, learning about colour, making tonal sketches and thinking about planning your work. Now, let's get to work!

We're going to do some finished paintings, using the techniques described earlier.

Don't forget, where I have made little sketches to sort out the compositions, you should follow me and do the same.

We will start with a simple landscape in three colours and white, then go on to do a simple still life with apples and grapes, then paint flowers in a landscape, fishermen in a harbour rowing a boat, and finally, using some more advanced techniques like glazing, we will paint a townscape.

Each step is clearly described so you can paint along with me. Don't worry if yours looks different from mine: everyone will include their own ideas, and that's how you develop a distinctive style. I run regular painting courses and holidays, and it is amazing how, in a group, everyone's painting looks different, even if they use the same colours and paint the same subjects. That is how it should be.

Tamar Valley
560 x 407mm (22 x 16in)

This painting of the Tamar Valley, in Cornwall, was painted using a style known as 'divisionism', favoured by artists such as Camille Pissaro. It is built up in individual brush strokes, with each stroke remaining separate. I find this a very satisfying way of working, as the little touches of paint have very subtle effects, especially if the tones are carefully controlled.

Landscape in Three Colours

There are many subjects that lend themselves to treatment with a limited palette, where tone assumes an important role. This simple moorland scene is an example, since it is painted in only three colours plus white. Remember that the thumbnail sketches, shown below, are as important as the actual painting.

When beginning an image like this, it is important to decide early on what kind of mood or atmosphere you want to impart. As this is a distant, fairly desolate part of the landscape of Devon, I want to show a small-scale wilderness, where the habitation is dwarfed by the landscape.

You will need

Board

Gesso tinted with burnt sienna acrylic paint

Low odour thinners

Clean rag

Painting knife

Brushes: large household, no. 6 round, no. 6 flat, no. 2 flat, no. 4 filbert

Colours: French ultramarine, burnt sienna, lemon yellow, titanium white

Scrap paper

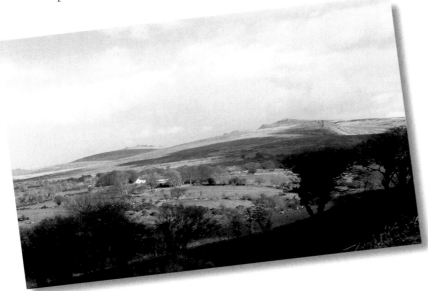

When working from a photograph, start by making some thumbnail sketches. Leave out anything that does not add to the overall composition. It is as important to decide what to leave out, as what goes in.

Here I have made my tonal sketches very simple, deciding to use only those elements that I felt were important enough to be included. I have tried to abide by these early decisions right through the painting.

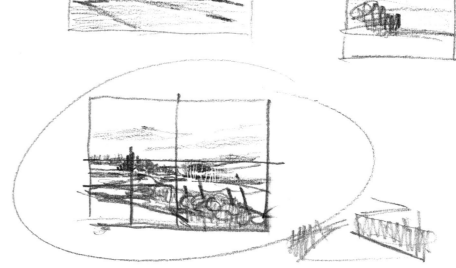

44

Tip

Acrylic colours are useful for blocking in areas of your painting before you start using oils, as they dry very fast. Make sure you put all the acrylics away before starting to use oils, so as not to mix them up.

1. Tint the board using gesso mixed with burnt sienna acrylic paint and a large household brush. Leave to dry.

Tip

Get into the habit of setting out your colours on the palette in the same order every time you paint. Some dark colours such as blues and dark greens look similar as they come out of the tube. Knowing where each colour is will help you to avoid picking up the wrong one. Use a palette knife to mix paint.

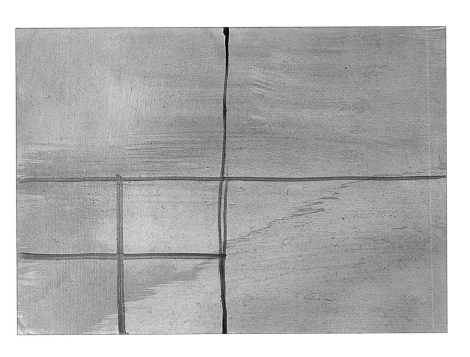

2. Using a no. 6 round brush and a mix of French ultramarine and burnt sienna thinned with low odour thinners, lay out a simple grid on the tinted board. Divide the board into four, and then divide the bottom left-hand rectangle into four as well. This will help you to transfer the various sections of the painting from the chosen thumbnail sketch, which is ringed on page 44 opposite.

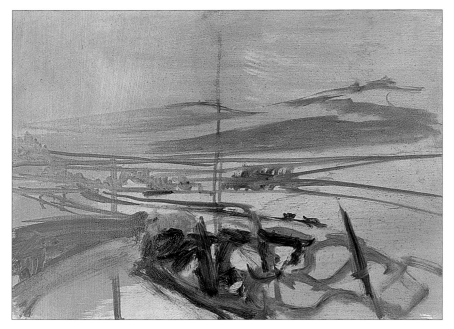

3. Transfer the main outlines of the scene from the sketch using the same brush and blue/brown mix. Using a warmer mix with more burnt sienna, sketch the outlines of the wall in the foreground. Remove unwanted grid lines using a clean rag.

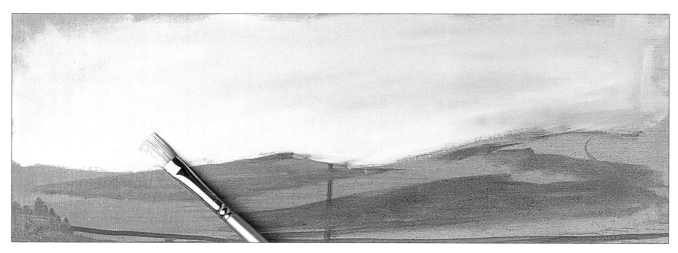

4. Block in the sky area using a no. 6 flat brush and white with a touch of French ultramarine and burnt sienna, barely diluted.

Tip

Start every painting using a large brush and continue with large brushes for as long as you can. Working with a small brush leads to tight, fiddly work and is very time consuming.

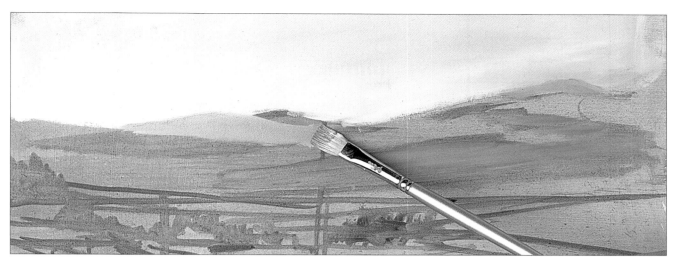

5. Block in the distant hills and the shadowed areas of the middle distance using the no. 6 flat brush and a mix of blue and white with a touch of the blue/grey from the sky.

Tip

When painting on coloured board or canvas, allow some little touches of the background colour to show through here and there. This has a harmonising, unifying effect.

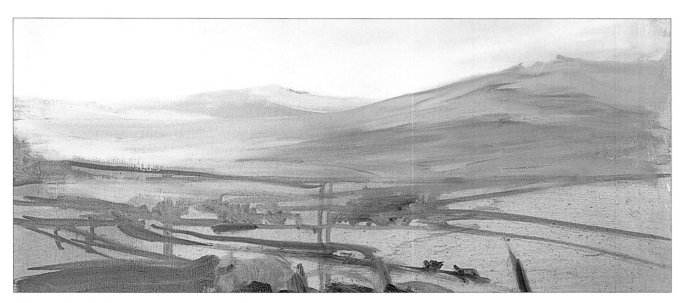

6. Strengthen the browns showing between the blue areas in the distance using a mix of lemon yellow, white and burnt sienna.

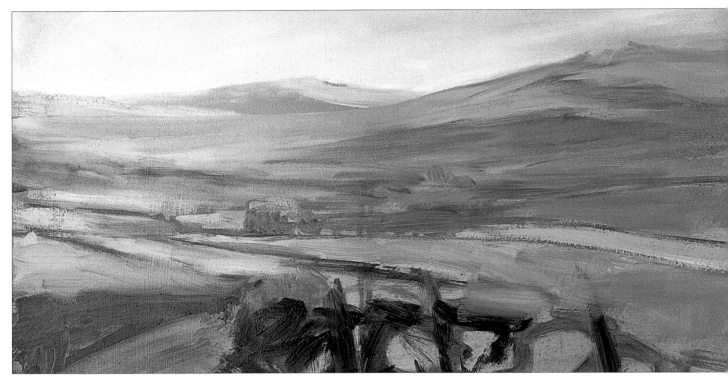

7. Mix lemon yellow and French ultramarine with white and use the no. 6 flat brush on its edge to block in the fields. Add more blue for the distant fields.

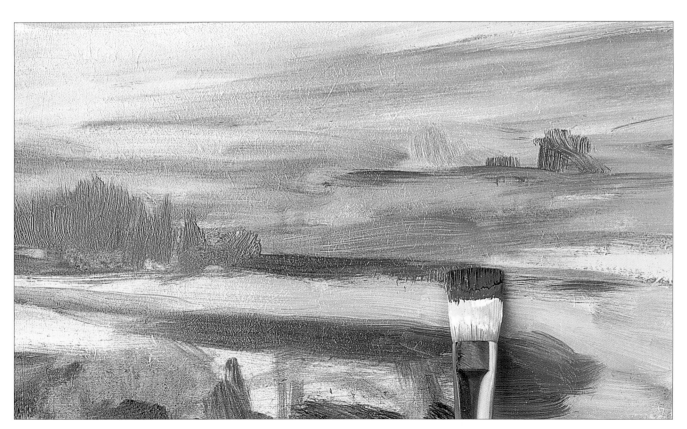

8. Paint the hedges using a darker green with burnt sienna added, and moving the brush from side to side.

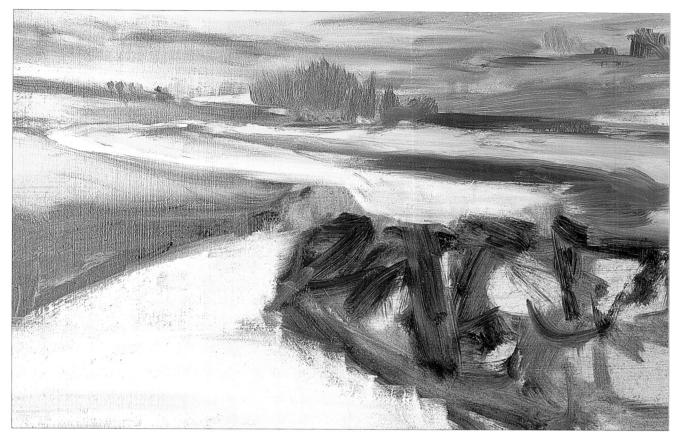

9. Using the no. 6 flat brush and a mix of white and burnt sienna, paint the road. Add a touch of ultramarine as it recedes into the distance.

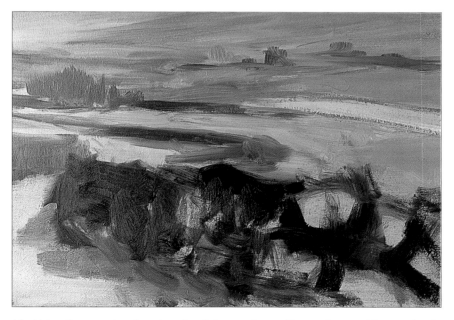

10. Using the same brush and a mix of ultramarine and burnt sienna with a touch of white, darken the stone wall in the foreground.

11. Add cloud shapes using irregular brush strokes of the no. 6 flat and a little white with lemon yellow.

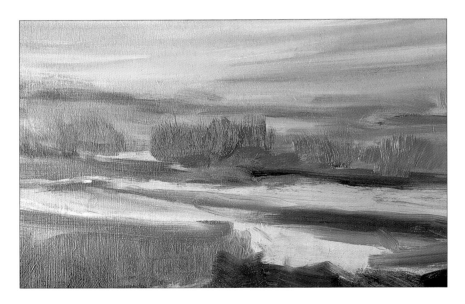

12. Using a mix of burnt sienna and French ultramarine, add some brownish trees, flicking upwards with the no. 6 flat to create the tree shapes.

13. Using the tip of a painting knife, scrape back some paint to describe the shape of the farmhouse.

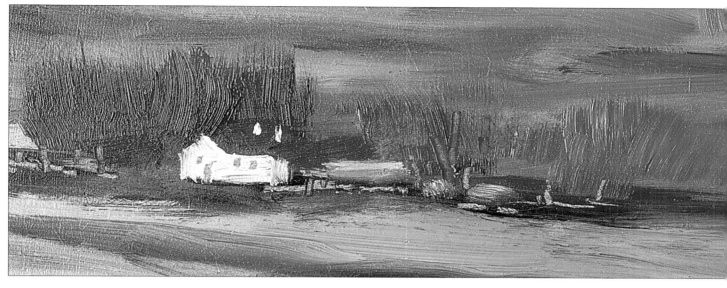

14. Continue with the same scraping back technique to establish the tree trunks. Paint the house using a no. 2 flat brush and white with a tiny touch of burnt sienna. Use the sharpened end of an old paintbrush and the sgraffito technique to put in the windows and door.

15. Take the no. 4 filbert brush and a mix of white and burnt sienna with a touch of ultramarine and paint the stones of the stone wall. Use irregular strokes and let the dark underpainting show through.

16. Mix lemon yellow and a touch of ultramarine on your palette and scrape some off on to the edge of a piece of scrap paper. Use the paper to apply the foreground grasses.

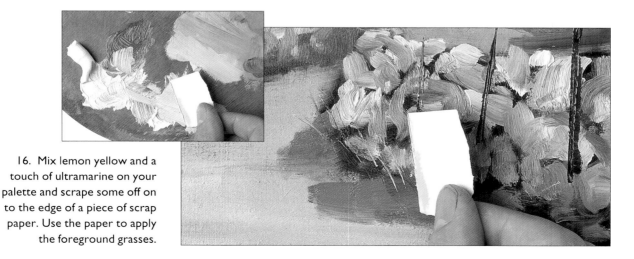

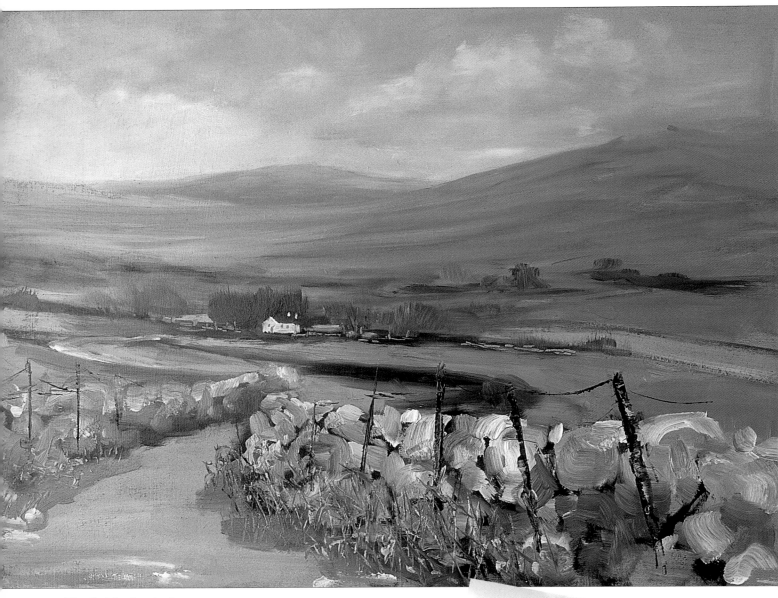

The finished painting

403 x 300mm (15⅞ x 11¾in)

I have completed the painting by adding some fence posts, applied using a knife edge and a mix of ultramarine and burnt sienna. It is worth looking back now at the original source photograph to see how the painting differs from it. I wanted to impart a feeling of a brooding wilderness that dwarfs any man-made influences. The little farmhouse, although a focal point, remains quite remote and insignificant.

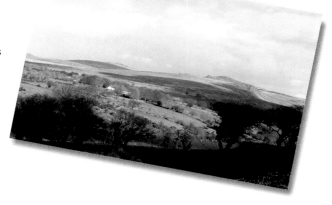

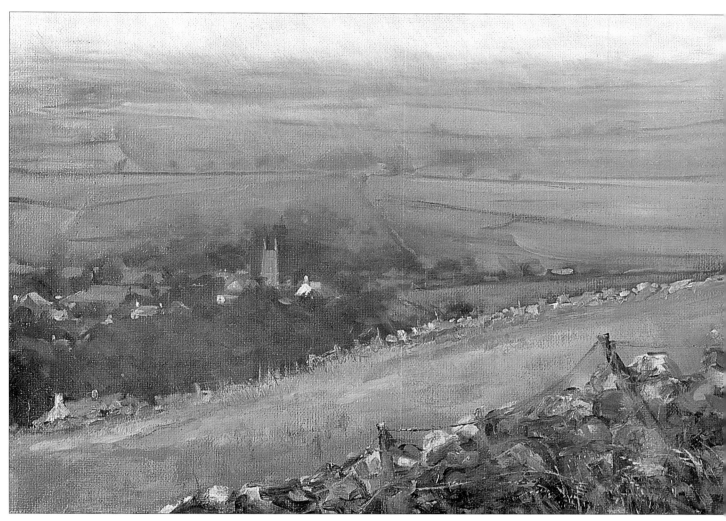

Petertavy on a Misty Day

407 x 305mm (16 x 12in)

I had intended to paint Petertavy on a sunny day but the weather changed shortly after I set my easel up and, having walked a considerable way to get to this site, I wasn't going to leave without a painting! As I discovered, it is quite difficult painting in conditions where there are no shadows and very little definition. I enjoyed the challenge however, and this is the result.

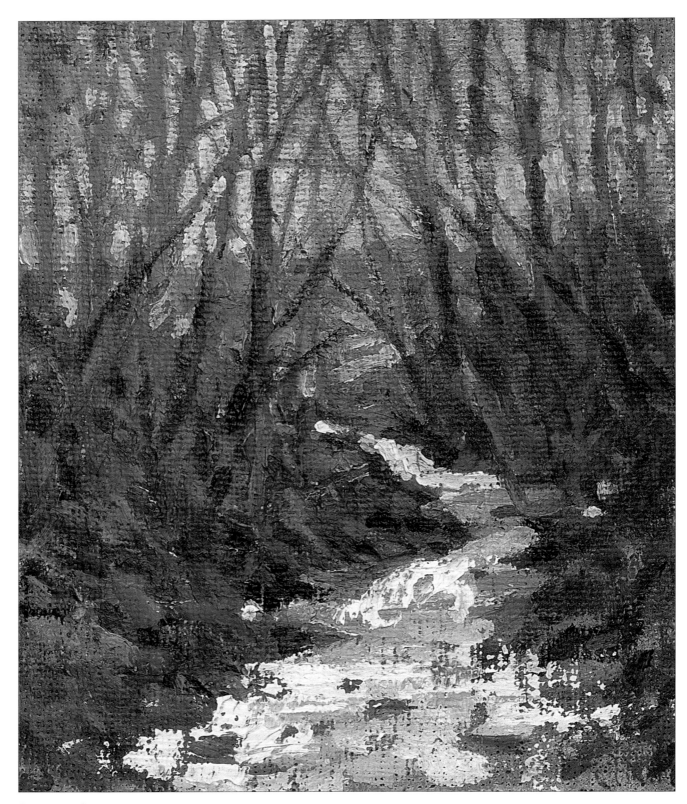

Dartmoor Stream

305 x 407mm (12 x 16in)

I enjoyed painting this landscape. It was done very quickly on coarse canvas, using big, bold brush strokes. I feel it captures the rugged strength and vitality of this piece of Dartmoor in a very loose and spontaneous way.

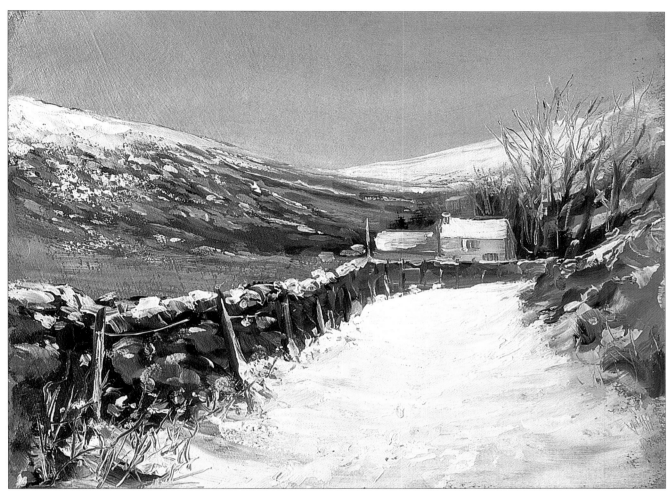

Dartmoor Winter

305 x 254mm (12 x 10in)

Drifted snow can be tricky to paint. Even in the cold, if there is any sun about, the snow is rarely pure white. Titanium white is a very cold colour, even for snow, and so I use a touch of Naples yellow in it to warm it up a little.

Moorland Farmstead

407 x 305mm (16 x 12in)

When I was a boy, growing up in a little village on the edge of Dartmoor in Devon, I often used to explore this group of old buildings. They had been abandoned for several years and always seemed to me to be in an idyllic situation: the wonderful little clapper bridge crosses the steam, and there are many fascinating stone circles and standing stones in the vicinity. Shortly after I painted this, the place was sold, and I haven't been back since to see what 'improvements' the new owners have made. I'll be surprised if the old rusty shed roof is still there – but it made a nice feature in this painting.

I did the painting in the studio at home as a demonstration, partly from sketches (see page 41) and partly from memory, and I think the orange and blue complementary colour scheme works well.

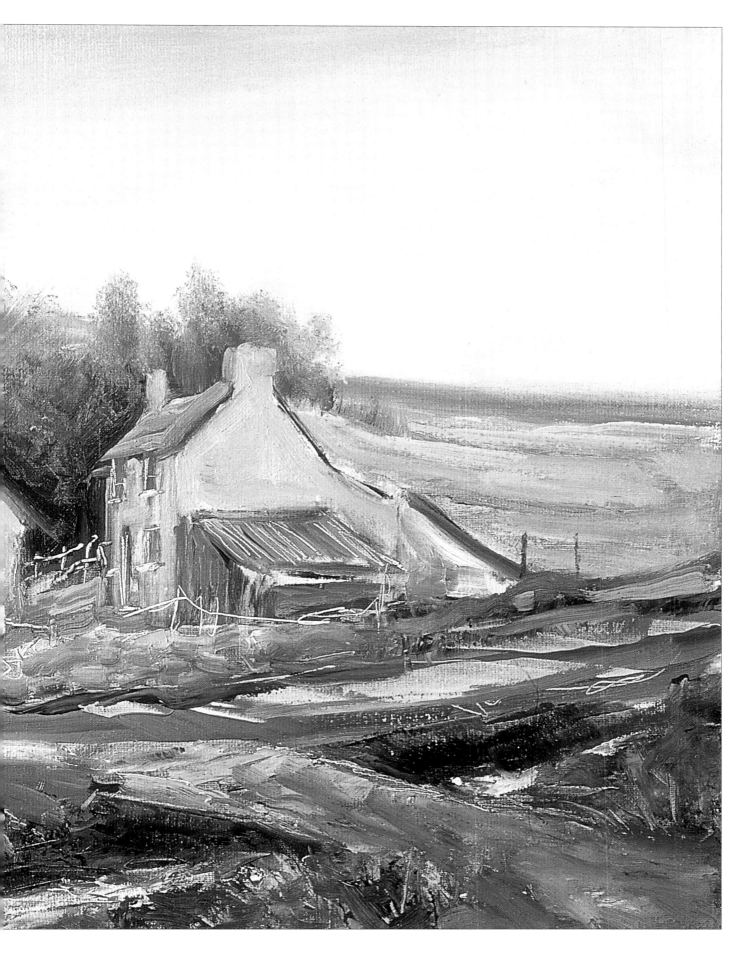

Still Life

A still life is an excellent subject to practise on. You have complete control over the subject, lighting, colours – everything. This still life is similar to the one shown on pages 26–27, but is painted using wet in wet techniques only. I have elected to paint from a slightly unusual viewpoint: I have placed the fruit at eye level on the shelf. This shelf is a strong horizontal, so I have broken it by allowing some grapes to hang over the edge.

Sometimes setting up a still life can take almost as long as painting it. To get the grapes to stay suspended where I wanted them, I had to use staples to anchor the stalks to the wooden shelf!

You will need

Board primed with gesso, tinted with burnt sienna acrylic paint

Low odour thinners

Brushes: no. 6 flat, no. 6 round, no. 2 flat, no. 2 round

Colours: burnt sienna, French ultramarine, lemon yellow, phthalo blue, titanium white, Naples yellow, cadmium yellow deep, cadmium red light, permanent rose

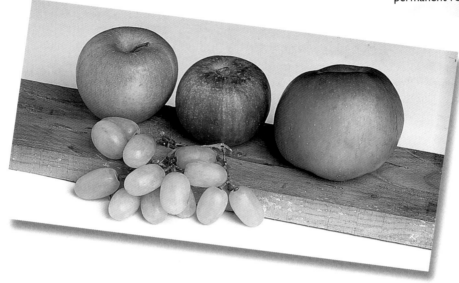

1. When the background tint is completely dry, take a no. 6 round brush and sketch the elements of the scene using a dilute mix of burnt sienna and ultramarine.

2. Block in the background using a no. 6 flat brush and a mix of lemon yellow, phthalo blue and white with a touch of Naples yellow. Use a slightly darker mix for the area under the shelf and for the shadows around the apples.

Tip

When painting a portrait or still life, treat the background as an important part of the painting. Sometimes it is best to establish the background first, so that the subject does not appear to float on the canvas.

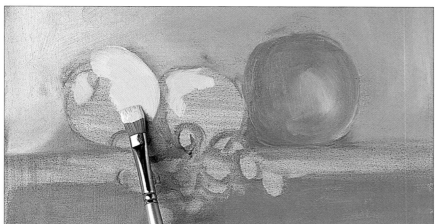

3. Paint the green apple using the same brush and a mix of lemon yellow and cadmium yellow deep with touches of phthalo blue and white. Paint the top of the middle apple and block in the apple on the left with yellow made from lemon yellow, a little Naples yellow and white.

4. Paint in the warm orange/pink on the left-hand side of the red apples by adding a touch of cadmium red light to the yellow mix. Mix cadmium red light and permanent rose with a touch of burnt sienna and brush in the dark red part of the middle apple. Use the loose, spontaneous brush strokes of the scumbling technique so that the underpainting shows through, and follow the form of the apple.

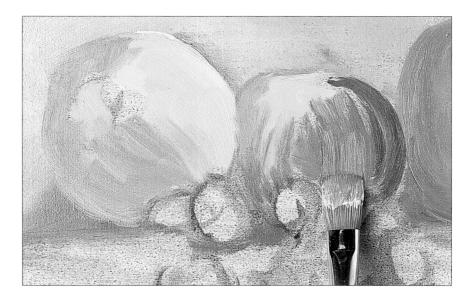

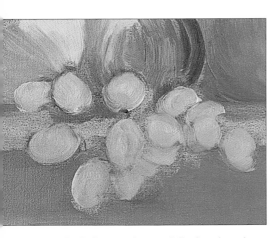

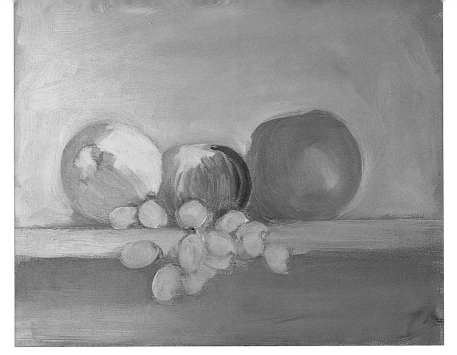

5. Still using the no. 6 flat brush and a mix of lemon yellow, cadmium yellow and white with a tiny hint of phthalo blue, block in the grapes.

6. Paint in the shelf using a mix of Naples yellow, white and burnt sienna. Adjust the background tones, making parts of it lighter using white with a touch of cadmium yellow deep.

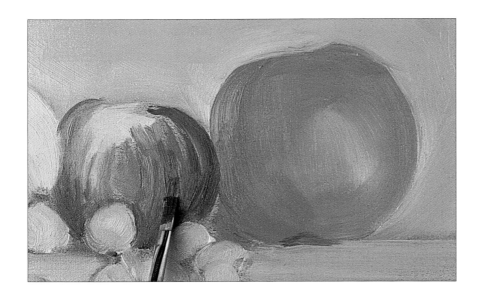

7. Mix a mid-green from lemon yellow, cadmium yellow deep, phthalo blue and white and darken the left-hand side and base of the green apple, giving it form. Change to a no. 2 flat brush and use a mix of permanent rose and burnt sienna to add darker tones to the right-hand side of the red apple.

8. Using the no. 2 flat brush and a mix of cadmium red light, cadmium yellow deep and white, paint in the pinkish streaks on the left-hand apple. Add streaks of the same mix to the top of the large green apple.

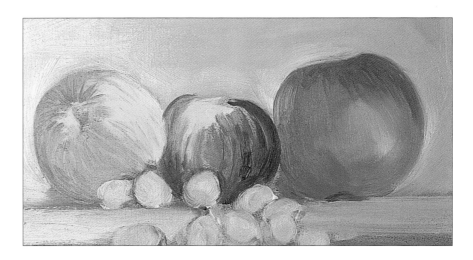

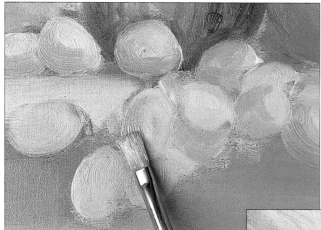

9. Establish the darker tones of the grapes using the same brush and a mix of lemon yellow, cadmium yellow deep, white and a touch of phthalo blue.

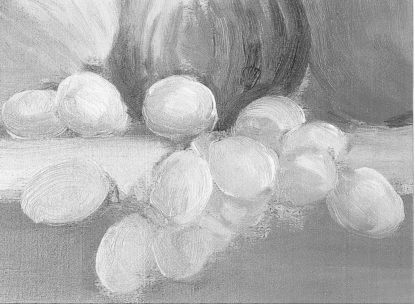

10. Add highlights to the grapes using the no. 2 flat brush and touches of white.

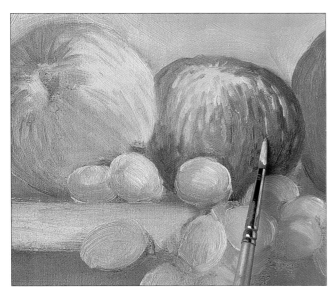

11. Change to the no. 2 round brush and use a mix of cadmium yellow deep and white to paint yellow flecks on the central apple, then do the same to the apple on the left.

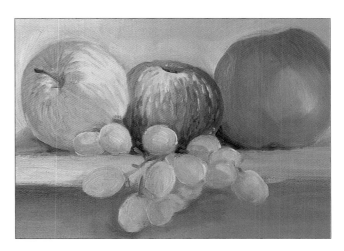

12. Mix burnt sienna and a touch of phthalo blue and use the no. 2 flat brush to paint the stalk of the left-hand apple, the stalk hole in the middle apple and the grape stalks. Apply the shadow under the grapes with a darker mix of the background colour; lemon yellow, Naples yellow and white with a touch of phthalo blue.

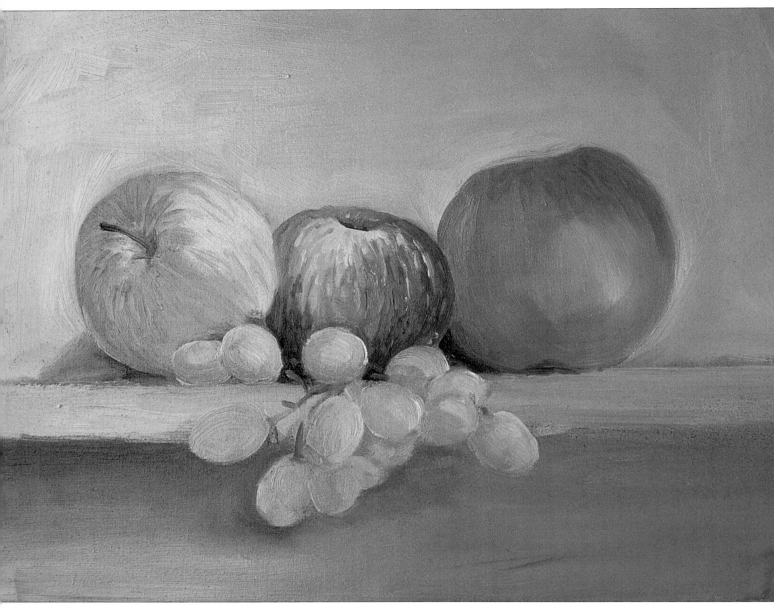

The finished painting

300 x 255mm (11¾ x 10in)

A nice effective still life, making good use of the complementary
colour scheme of green and red.

Daffodils and Catkins

407 x 305mm (16 x 12in)

I was attracted by these flowers, illuminated by artificial light, with the dark evening
colour glimpsed through the window almost matching the blue of the jug. This was
painted on the spot, very briskly, while the excitement of the image was fresh in my mind.

Daffodils

Rarely, for me, I began this painting on a plain white surface. Usually I like to work on a coloured ground, but in this case the brightness of the daffodils works best if painted on to a light background. The textures of the grasses and stalks in dark greens and browns are important here. It is easier to impart some texture early on, then wipe out the blooms, than it is to paint round them.

You will need

Canvas board
Household brush
Alkyd gel
Low odour thinners
Kitchen paper
Painting knife
Brushes: no. 6 round, no. 6 flat, no. 2 long flat, no. 2 round, fan blender
Colours: French ultramarine, lemon yellow, burnt sienna, titanium white, Naples yellow, sap green, phthalo blue and cadmium yellow deep

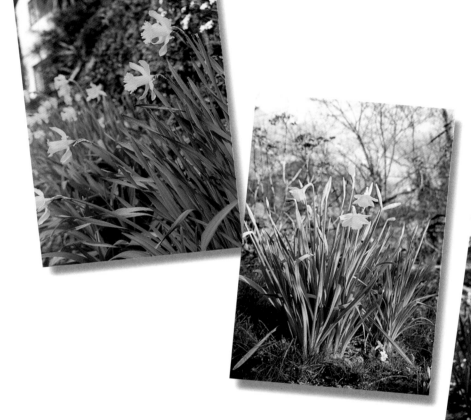

I have chosen three photographs for my source, and I will take elements from each to combine into a pleasing composition. I especially like the shape of the single daffodil and the background trees. One flower on its own would look a bit lonely, so I'm going to include some others, making sure that they are not too separate, as that would look unnatural. It is important to remember, as we work, that we are painting a group of blooms, and not a collection of individuals! Some of them must overlap and be partly hidden.

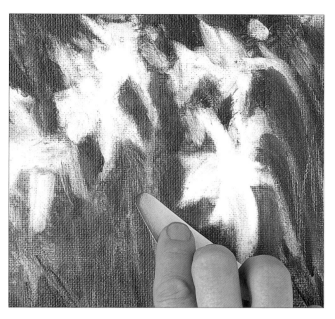

2. Dampen a piece of kitchen paper with thinners and lift out the paint back to the canvas board to show the position of the main daffodil blooms.

1. Add alkyd gel to a dark green mix of ultramarine, lemon yellow and burnt sienna, to speed up the drying process, and using a household brush, block in the main shapes of the background trees, adding just a touch of thinners to the mix to cover the foreground area at the bottom.

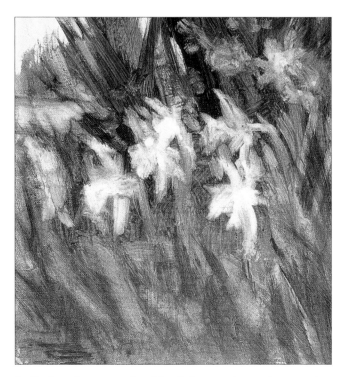

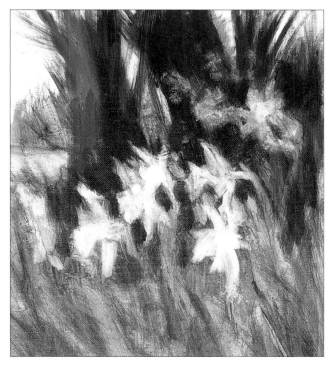

3. Darken the green mix with a little more burnt sienna and, using the no. 6 flat brush, add some green/brown foliage shapes in the foreground.

4. Using the same brush and a mix of burnt sienna, ultramarine and a touch of white, darken the background trees.

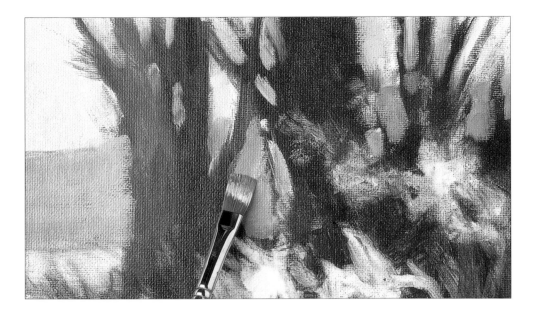

5. Block in the sky using the no. 6 flat brush and a mix of white with touches of Naples yellow and ultramarine. Paint the distant hill using white and a little ultramarine.

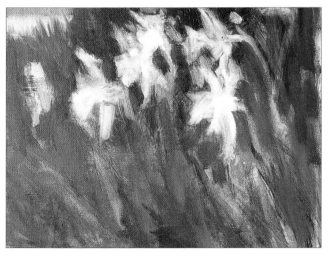

6. Mix sap green with a touch of phthalo blue and use the no. 6 flat to brush the paint on loosely, darkening the foliage area below the daffodils.

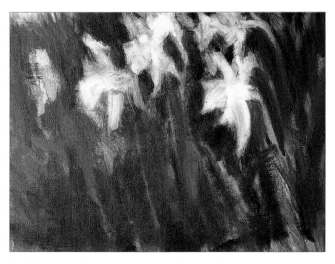

7. Change to the no. 6 round and make this area darker and warmer at the bottom with an almost undiluted mix of sap green and burnt sienna. Brush on the paint in vertical strokes.

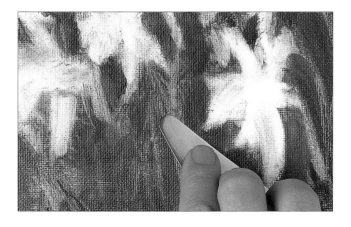

8. Scrape the paint back with the tip of the painting knife to establish the leaf shapes.

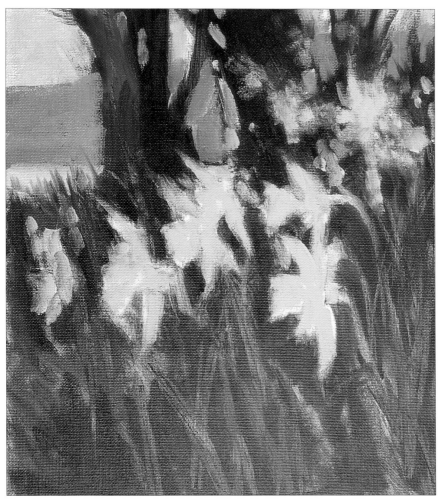

9. Block in the daffodils using the no. 2 flat brush and a mix of undiluted lemon yellow with touches of cadmium yellow deep and white.

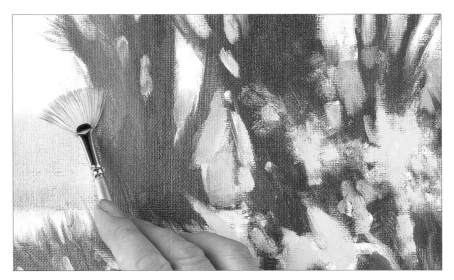

10. Using the fan blender, work into the background, softening the edges of the tree trunks to impart a feeling of distance.

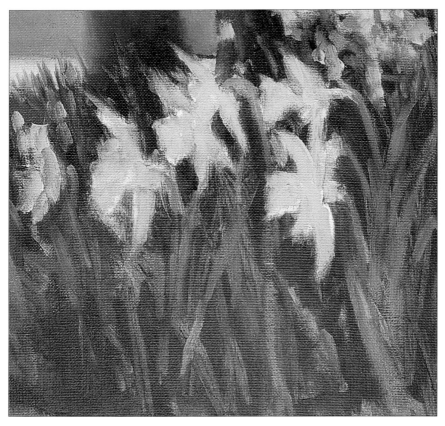

11. Using the no. 2 long flat brush, sometimes on its edge, and a mix of sap green with a touch of phthalo blue and white, paint in the leaves and the stalks with a flicking motion towards the tip.

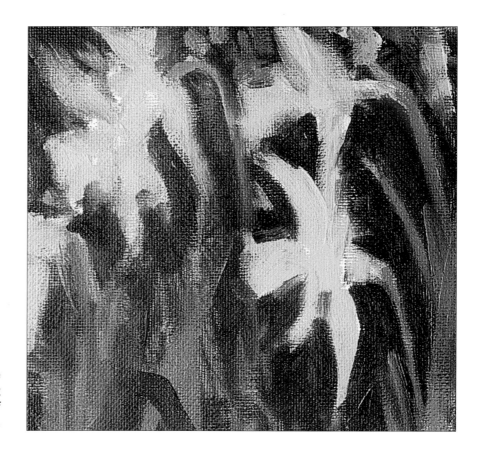

12. Define the edges of two or three blooms by painting round them using the no. 2 long flat brush and a mix of sap green and phthalo blue.

13. Using the same brush and a mid-green mix of sap green, burnt sienna and a touch of white, suggest the ivy on the trees. Add spots of light showing through the branches with a mix of white, a touch of Naples yellow and a tiny touch of cadmium yellow deep.

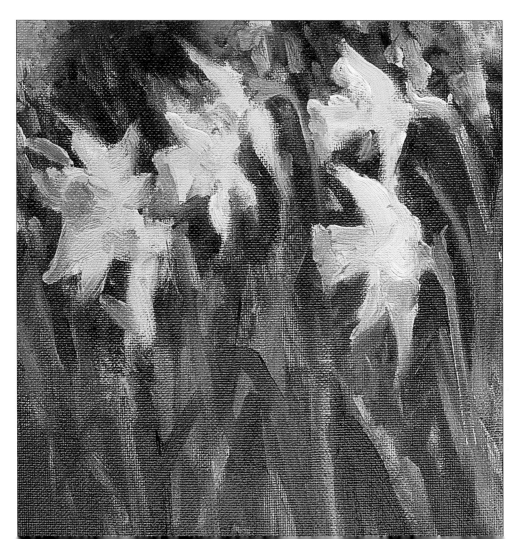

14. Add the final details to the main group of daffodils using the no. 2 long flat brush and a mix of lemon yellow, cadmium yellow deep and white. Enhance the three-dimensional look of the foreground by darkening the gaps between the leaves and stalks with a mix of sap green and phthalo blue, with touches of burnt sienna here and there. Change to the no. 2 round brush and a mix of white with tiny touches of sap green and lemon yellow to add touches of highlight to the leaves.

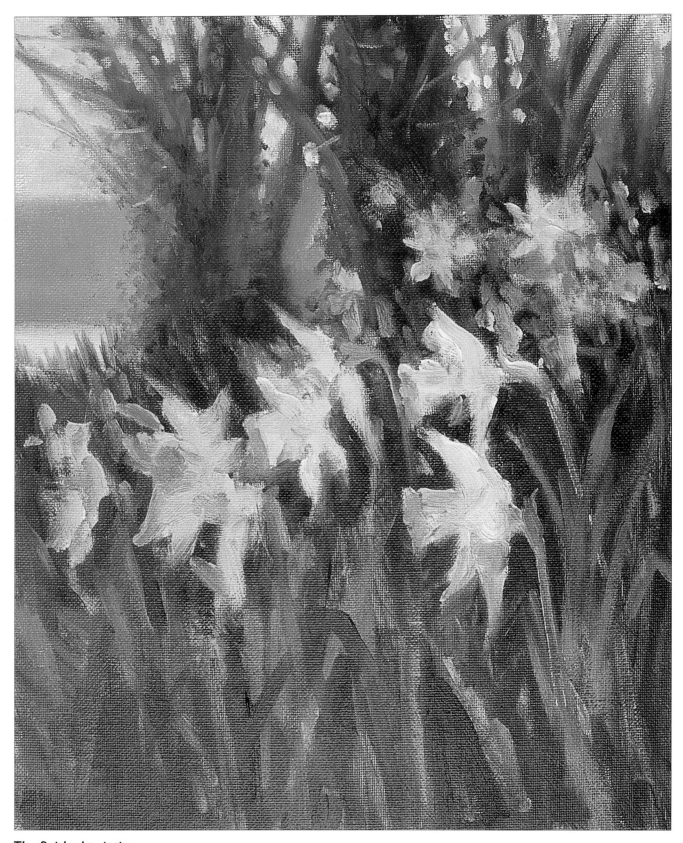

The finished painting

276 x 353mm (10⁷/₈ x 13⁷/₈in)

I'm quite pleased with the final result. The background, which is soft and fuzzy, makes the flowers more important, and lends distance to what is really a fairly enclosed scene. I've avoided the tendency to make every daffodil crisp and accurately painted, so the image is more about the light on the flowers.

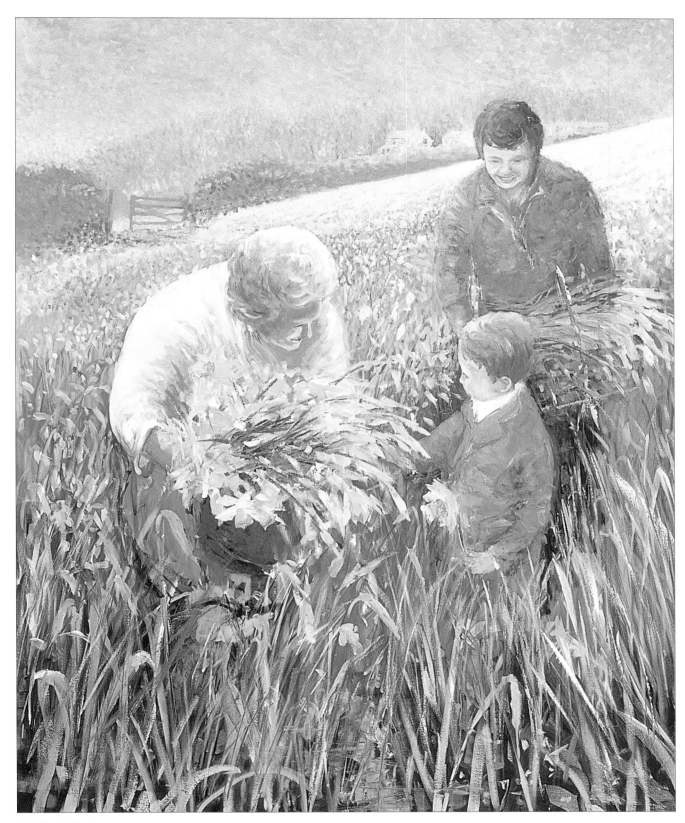

Daffodil Pickers

107 x 87cm (42 x 34in)

This painting captures a bygone era, when the valley where I live was full of little fields, each growing a different variety of early daffodil. Picking was very much a family affair, and I can remember being taken out as a very small boy to 'help' work in the fields, and feeling very proud. This image was composed using old photographs from the village archives, and a lot of memories.

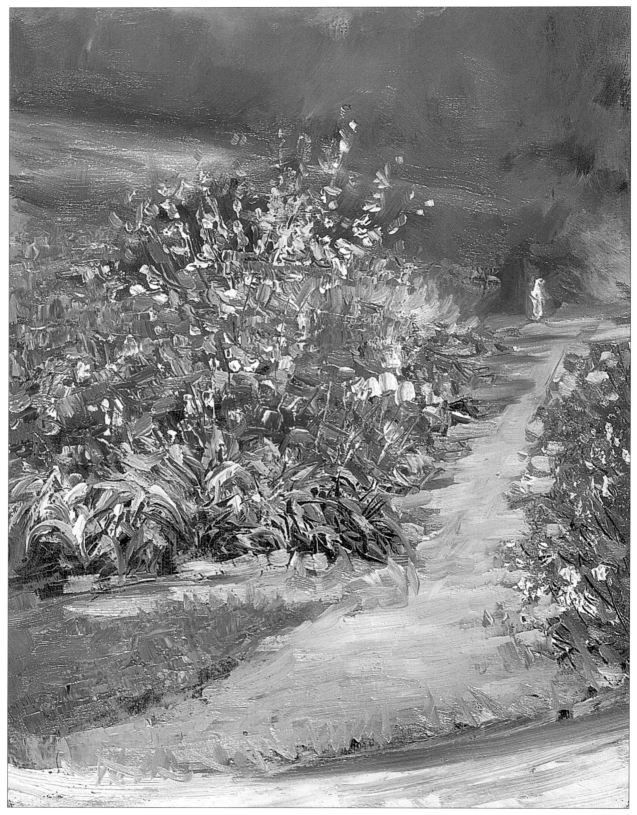

Bickleigh Gardens

254 x 305mm (10 x 12in)

This was painted as a demonstration during a painting holiday I tutored in Devon. It
was a very hot day, so the choice of subject was a compromise; a nice view, 'as long
as we can all sit in the shade'! It was painted quickly, in about forty minutes, using
mainly knives and fingers.

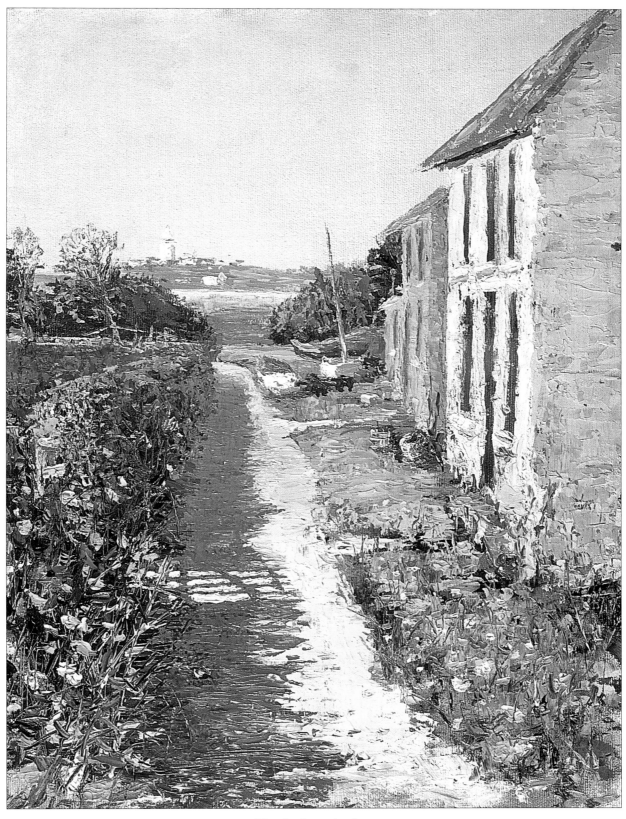

The Path to the Sea

304 x 407mm (12 x 16in)

This is a good example of a composite image. The foreground, including the shadow of the gate,
was taken from a sketch I made near Richmond Park in Surrey. The cottages are part of a row of
houses in Dorset, and the distance is a part of St Agnes, one of the Isles of Scilly off the Cornish
coast. So the actual view doesn't exist, but that's no reason not to do a painting of it!

Fishermen

This image is very reliant on the figures. They need to be painted in the same loose style as the rest, otherwise they will look different from the other parts of the painting. It is a very tonal image, with the brightness of the cottages contrasting with the dark water, and the lighter reflections distorted by the ripples. The cottages are linked visually to the figures by the flagpole, and there is a nice complementary colour combination in the green jacket and the red boat.

Several people have asked me why the figures are standing up in the boat. This is a technique used to manoeuvre a boat in a crowded harbour, where there is no room to reach the oars out sideways.

You will need

MDF board primed with gesso tinted with burnt sienna
acrylic paint
Low odour thinners
Alkyd gel
Kitchen paper
Brushes: no. 6 flat, no. 6 round, no. 4 flat, no. 2 flat, no. 2 round, no. 2 long flat
Colours: burnt sienna, ultramarine blue, Naples yellow, lemon yellow, cadmium red light, permanent rose, lemon yellow, phthalo blue, titanium white

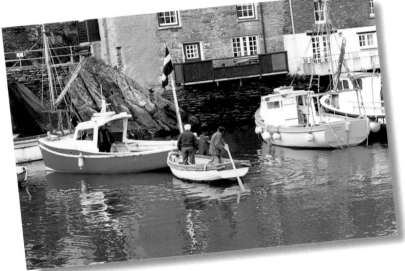

When working from a photograph, the temptation is to make a literal copy of it. This is something you must work hard to avoid! Here, the dark area to the left of the red boat is a distraction, and the jumble of masts and rigging on the right of the image is liable to draw the eye out of the painting.

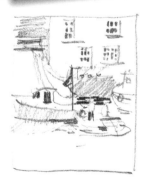

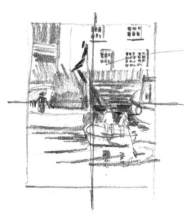

In order to simplify the composition and rearrange things, I make a few thumbnail sketches so I know where to place the main elements. This can save a lot of alterations later. It is like making visual notes to refer to as I paint. I jot down ideas as well, like putting a figure in the doorway.

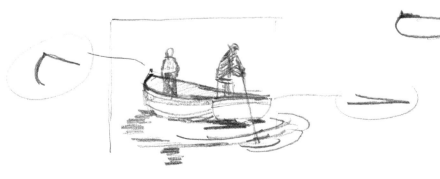

The boat shape is quite difficult. It helps to draw it first, especially the area of bow and stern, where there are some tricky bits. Doing this helps to resolve the problem of angle and shape.

74

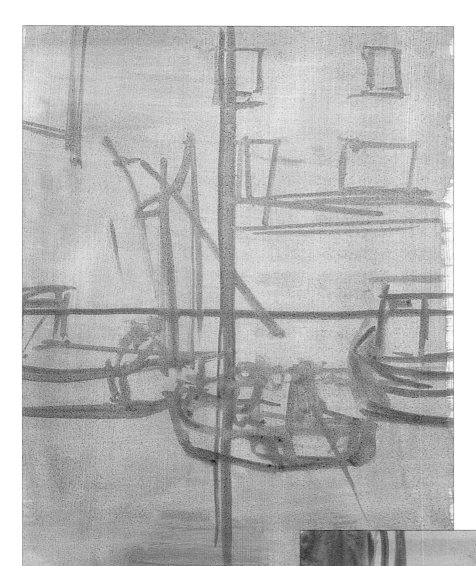

1. Thin a mix of burnt sienna and ultramarine using low odour thinners. Using a no. 6 flat brush and applying the paint sparingly, transfer the grid and the main elements of the scene from the sketch.

2. Block in the darker tones using the same mix and a no. 6 round brush.

3. Lift out the shapes of the two figures using a piece of kitchen paper.

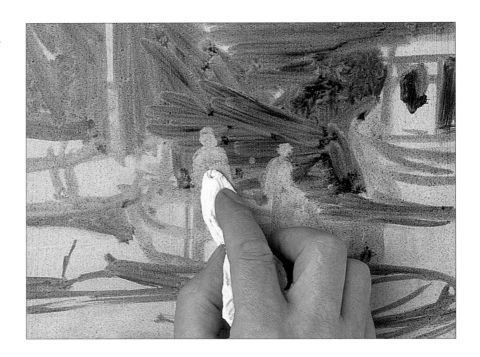

4. Block in the background using the no. 6 flat brush and a mix of burnt sienna, ultramarine and Naples yellow. Use the paint almost undiluted but brush it out to a thin layer in places.

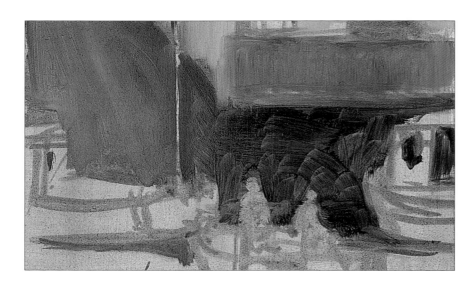

Tip

The figures can be altered at this stage if necessary by painting round them to adjust the shape of the outline.

5. Using the same brush and a mix of lemon yellow, ultramarine, Naples yellow and a little burnt sienna, block in the mid-tones of the water.

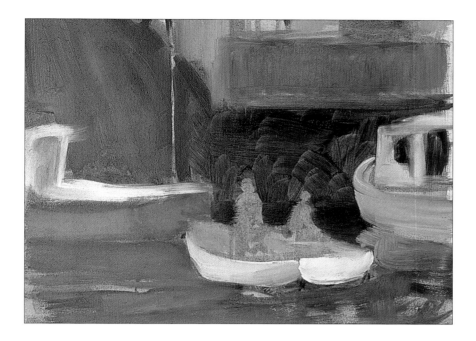

6. Block in the boats. Use a mix of cadmium red light and permanent rose for the red boat, and a mix of lemon yellow, phthalo blue and white for the blue-green boat. Paint in the reflection of the red boat as a simple shape using the same colours as the boat plus a touch of green. Then paint the dinghy using a tiny touch of French ultramarine and burnt sienna added to white to make a pale grey. Make the stern slightly lighter than the sides.

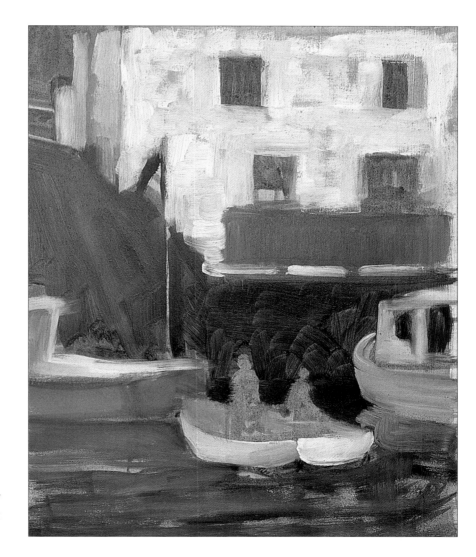

7. Paint the white building using the no. 6 flat brush and a mix of Naples yellow, burnt sienna, ultramarine and white. Work from the top down, using stiff, undiluted paint and irregular brush strokes to show the texture of the whitewashed stone wall. Leave some of the background colour showing through to enhance this effect.

77

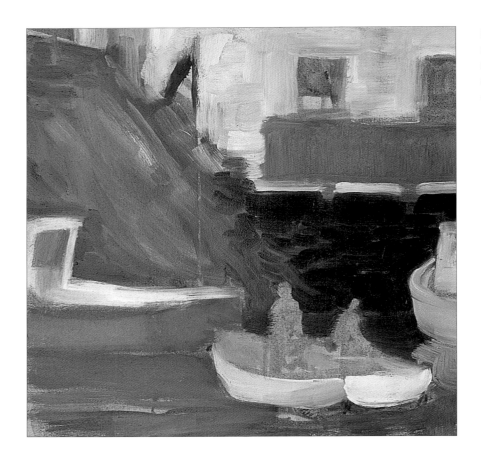

8. Add texture and highlights to the rocky outcrop using a mix of burnt sienna, ultramarine and white. Make sure your brush strokes follow the shape of the rock formation.

9. Add reflections in the water using a paint mix similar to that used for the building. Use the no. 6 flat brush on its edge at times, and let the brush strokes determine the shape of the ripples. Blend the colour with the green that is already on the palette to give a watery look. For the dark reflections, add a similar colour to that used for the rocks.

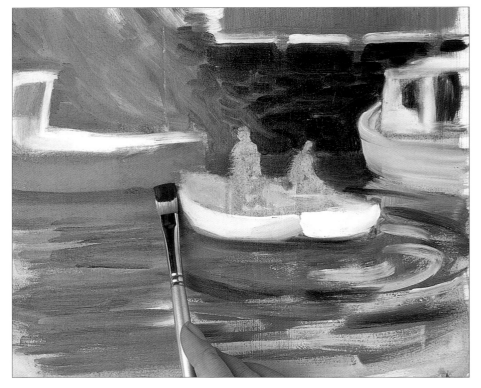

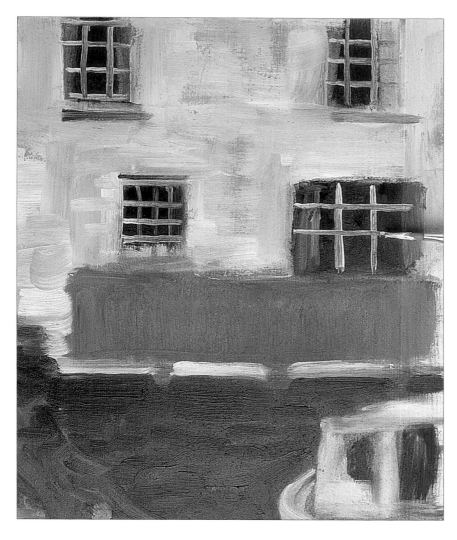

10. Take a no. 4 flat brush and pick up the darkest mix from your palette: the burnt sienna, ultramarine and Naples yellow used for the background. Paint the interior of the windows. Use the same mix as that used for the blue-green boat: lemon yellow, phthalo blue and white to paint in the woodwork.

11. Using the no. 2 flat brush and a pale mix of ultramarine and white, add the simple shape of a figure in four strokes.

12. Put in the cap using the same blue. Use a darker blue to add shadows under the arms and on the right of the torso. Keep the brush strokes bold and simple. Add highlights on the left with a touch of white.

13. Mix phthalo blue, lemon yellow and white and finish the other figure in the same way. Add the trousers using a grey similar to that used in step 8. Highlight the left-hand side with a paler mix, to impart form.

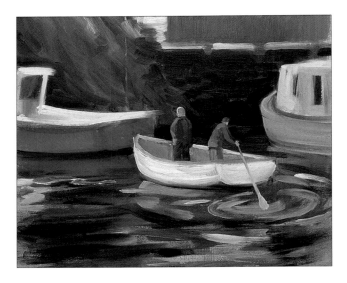

14. Mix Naples yellow and white and paint in the oar using the no. 2 flat and no 2. round brushes. Change to the no. 4 flat and paint the cabins of the boats with the same mix.

15. Add finishing touches to the painting using the no. 2 round brush and a range of colours from your palette. Put in the flagpole, then add the window recesses in the building colour, then the sharp reflections in the water. Sgraffito on the rowing boat to show the planking.

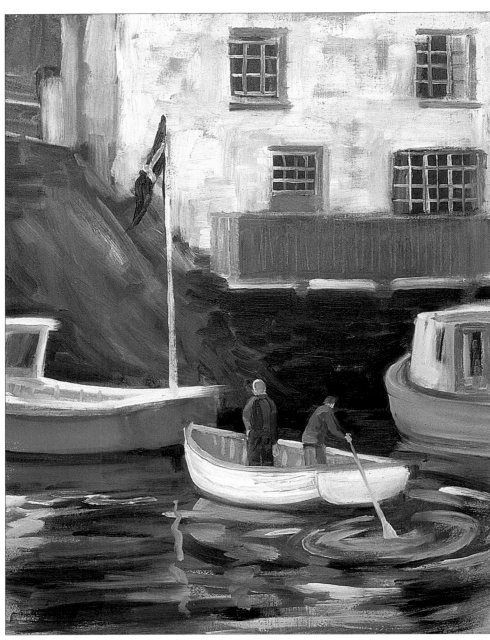

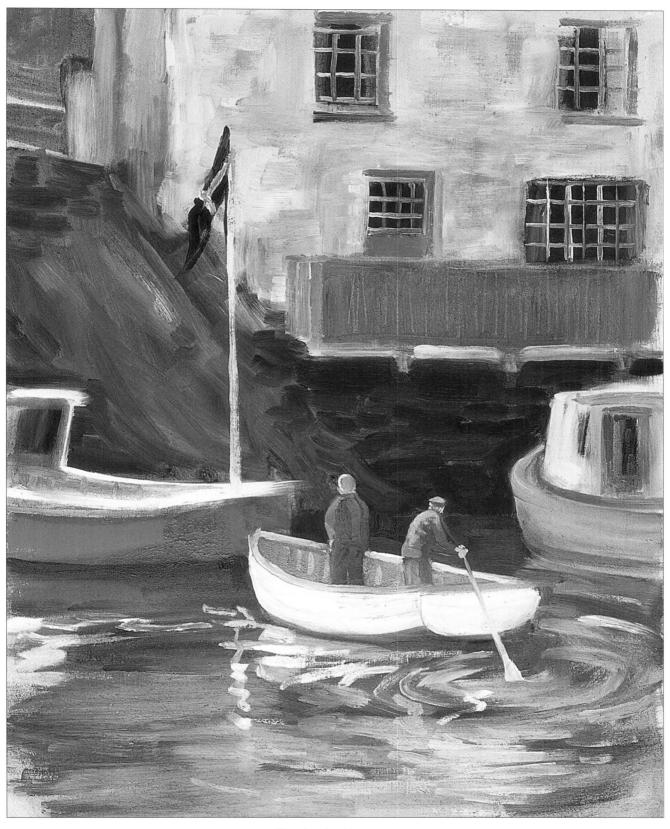

The finished painting

Final details were added using the no. 2 flat brush and the glazing technique. After allowing the painting to dry completely, I glazed in pale green on the water using a mix of lemon yellow, a touch of ultramarine and a tiny touch of white with alkyd gel. I then added a burnt sienna glaze on the building and inside the rowing boat. Using the no. 2 long flat brush and a mix of ultramarine blue and white, I added highlights to the ripples in the water and to the fisherman's blue jacket and cap.

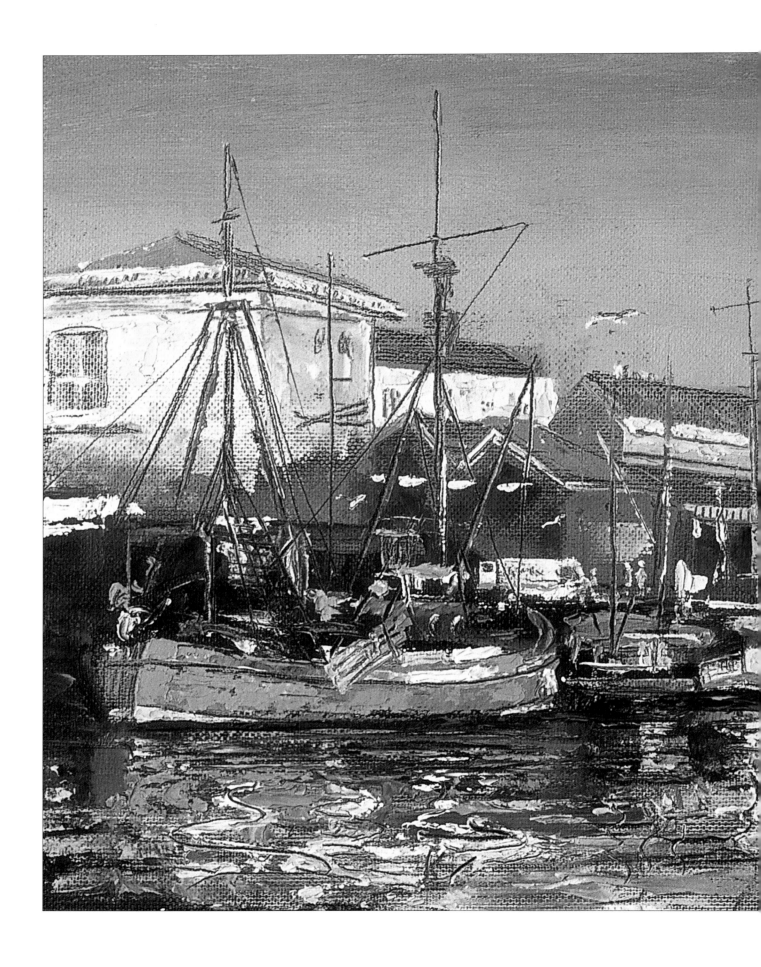

Plymouth Barbican

407 x 305mm (16 x 12in)

This vibrant image was painted using touches of strong colour to give a lively look which has plenty of movement. It was done on a board primed with a black acrylic gesso and the sgraffito technique was used to show the masts and windows. These details were scraped out using the sharpened handle of a paintbrush to reveal the dark colour of the primer.

The Thames Near Surbiton

508 x 380mm (20 x 15in)

These are residential boats, lived on permanently. I was very fortunate to live on such a vessel, and this is a view of my neighbours. I wanted to capture the quiet tranquillity, with the trees shielding the river from the noise and bustle of 'civilisation' beyond. This image relies heavily on the careful use of a complementary colour scheme to impart atmosphere, especially the violet/grey and pale yellow of the water. The painting was made from life, sitting on the aft deck of my boat. It is a very nice way to paint, as I could be out among nature, but never far from a cup of tea!

Richmond Hill

This is an image that relies on strong shadows for its impact. In this case, shadows are exaggerated because they are needed to link the two sides of the painting. The figure on the hill and the parked vehicles are painted very simply – they are implied rather than painted in detail. Good use is made of glazing, and the whole painting is done in a series of clearly defined stages. You should ensure that the painting is set aside to dry when the text recommends this, as this image uses a mix of wet in wet and wet on dry techniques. The addition of a little alkyd gel to all the paint mixes will make the painting dry quite quickly.

You will need

Canvas board primed with gesso tinted with burnt sienna acrylic paint

Alkyd gel

Pointed wooden stick

Clean rag

White plate

Brushes: no. 6 flat, no. 6 round, no. 2 flat, no. 2 round, no. 6 filbert

Colours: French ultramarine, burnt sienna, titanium white, Naples yellow, phthalo blue, cadmium red light, cadmium yellow deep, permanent rose, lemon yellow, sap green

Tip

Shadows do not have to be dull grey – try blues, violets, cool greens or turquoise to liven them up. Consider complementary colours: a yellow object such as a lemon in a still life could have a violet/grey shadow.

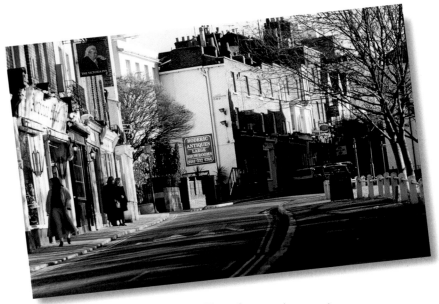

The reference photograph

1. Take the no. 6 flat brush and a diluted mix of ultramarine and burnt sienna, and paint a squared grid to help with the placing of the main elements of the composition.

2. Block in the simplified tones using the no. 6 round brush and a mix of ultramarine, burnt sienna and white diluted with alkyd gel to give a range of warm and cool greys.

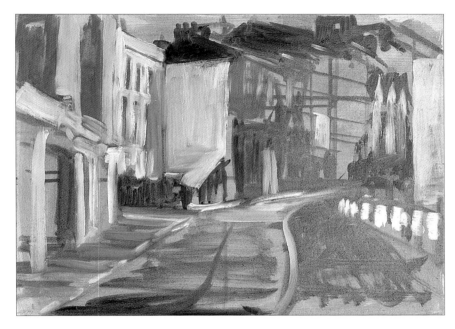

3. Mix white with burnt sienna, Naples yellow and ultramarine and dilute it with alkyd gel. Use the no. 6 round brush to establish the lighter tones.

4. Paint in the darker tones on the door, the shadows and the tree on the left using a mix of ultramarine, a touch of burnt sienna and a little white, diluted with alkyd gel. Leave the painting to dry.

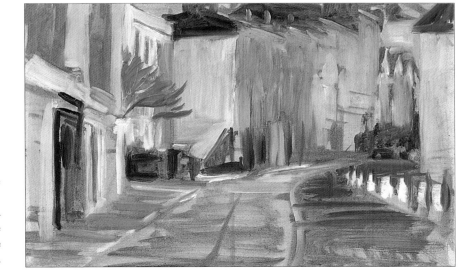

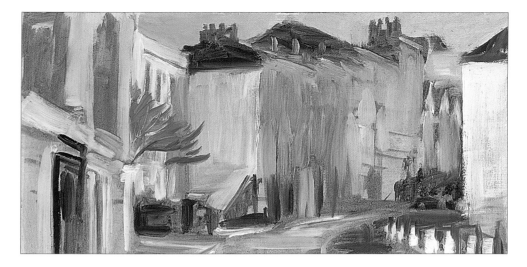

5. Paint in the sky using the no. 6 flat brush and a mix of ultramarine and phthalo blue with a touch of white. Add a touch of alkyd gel to the mix for each stage, as this will speed up the drying considerably.

6. Mix Naples yellow, burnt sienna and white with a tiny touch of cadmium red light and use the same brush to begin blocking in the buildings in the middle distance. Use the brush on its side to work between the windows.

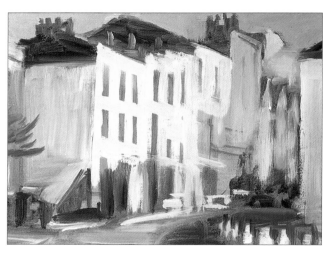

7. Continue painting the buildings in the middle distance, blocking in everything but the roof areas.

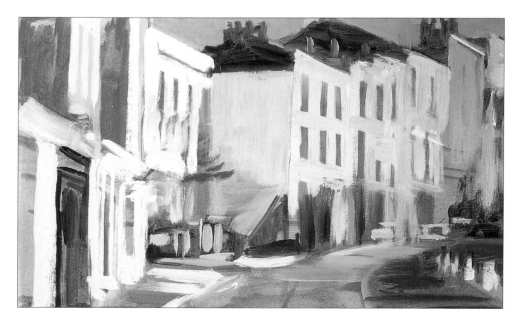

8. Using the same brush and a mix of white with touches of Naples yellow and cadmium yellow deep, block in the buildings on the left-hand side of the painting, leaving gaps to suggest windows. Paint over the blue area of tone painted in to suggest the tree.

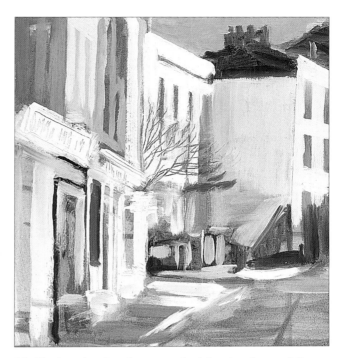

9. Use the sgraffito technique to establish the tree. Take a pointed wooden stick and lightly scrape paint away to allow the underpainted blue to come through.

10. Block in the shop fronts on the left using the no. 6 flat brush and a mix of French ultramarine and permanent rose with a little white added. Apply some touches of Naples yellow to the windowsills and above the door, using the same brush. Use the sgraffito technique to suggest lettering and architectural details in the foreground.

11. Mix permanent rose, ultramarine and burnt sienna with a lot of white to make a purple-grey tone. Use the no. 6 flat brush to block in the road, changing to the no. 2 flat to paint the thinner strip in the distance. Add more ultramarine for shadows and brush these in gently.

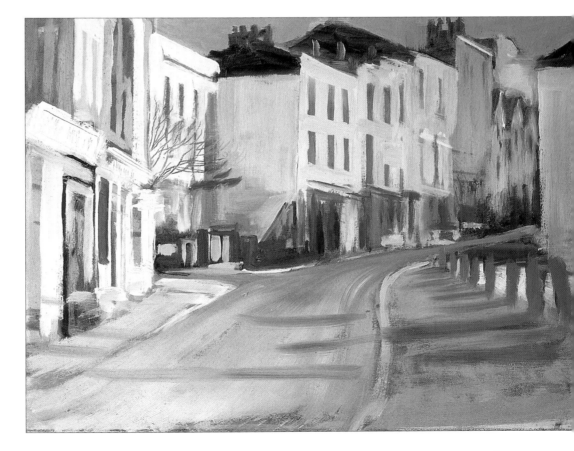

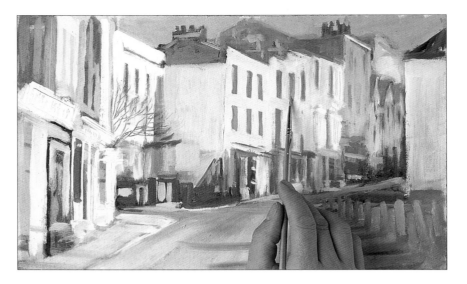

12. Lighten the roof area using the no. 2 flat brush and a mix of white, ultramarine, Naples yellow and a tiny touch of permanent rose. Lighten the chimney pots using a mix of white and burnt sienna. Block in the sign on the wall with Naples yellow, ready for overpainting when dry. Add lemon yellow mixed with white between the fence posts in the foreground. Mix a bright blue-green from phthalo blue and a little lemon yellow to paint the distant shop front up the hill, and add a touch of red above it to imply a hanging sign. Then redefine the windows using the roof colour and the no. 2 round brush.

13. Make a dark blue mix of ultramarine and a touch of burnt sienna and use the no. 2 flat brush to paint the pub sign on the left of the painting. Use a very pale grey mix and a no. 2 round brush to add highlights to the windows. Set the painting aside to dry. The addition of little touches of alkyd gel to all the mixes as this image was painted means that it should dry in a couple of days.

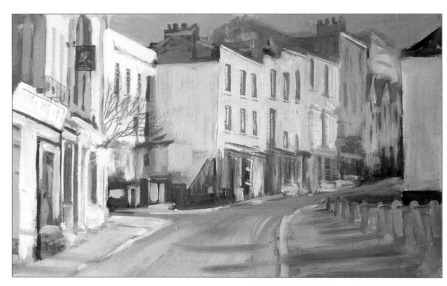

14. On a white plate, mix alkyd gel with small amounts of ultramarine and permanent rose. The white of the plate allows you to see how strong the glaze is.

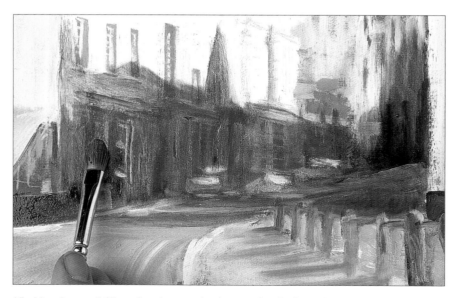

15. Use the no. 6 filbert brush to apply glaze to the shadowed area of the street. Use a blueish glaze for distance and a warmer mix with permanent rose added for the middle ground.

16. Lift out the shapes of the cars using a clean rag. Make two white mixes, one tinted with blue and one with green, and use a no. 2 round brush and fine brushwork to paint the cars. Suggest details using a pointed stick and the sgraffito technique.

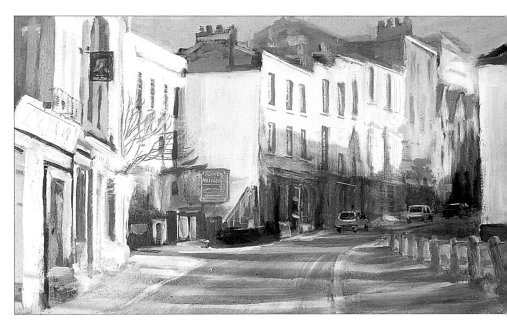

17. Paint the sign board brown using burnt sienna and Naples yellow, then suggest lettering using the sgraffito technique to allow the yellow underpainting to show through.

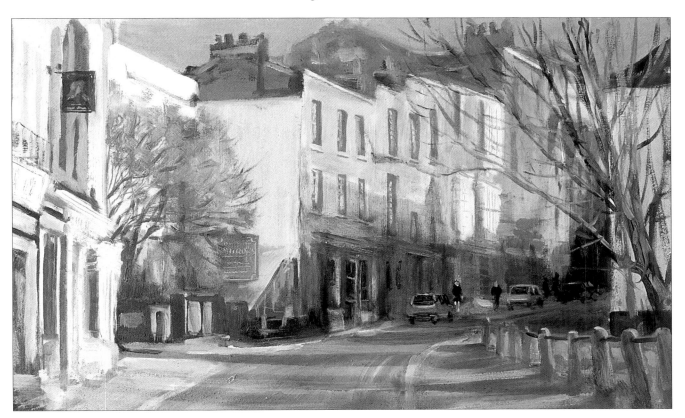

18. Make a weak orange glaze by adding tiny amounts of cadmium yellow deep and cadmium red light to alkyd gel. Using the no. 6 flat brush, glaze the foreground buildings. Mix ultramarine and burnt sienna with a touch of alkyd gel and, using the no. 2 round brush, paint the foreground tree. Add foliage to the tree on the left using the no. 6 filbert with a dry brush technique and a mix of lemon yellow with touches of sap green and white. Add touches of Naples yellow and cadmium yellow deep to the highlights. Create an impression of the figures on the hill using a dark mix of ultramarine blue and burnt sienna, applied with the no. 2 round brush.

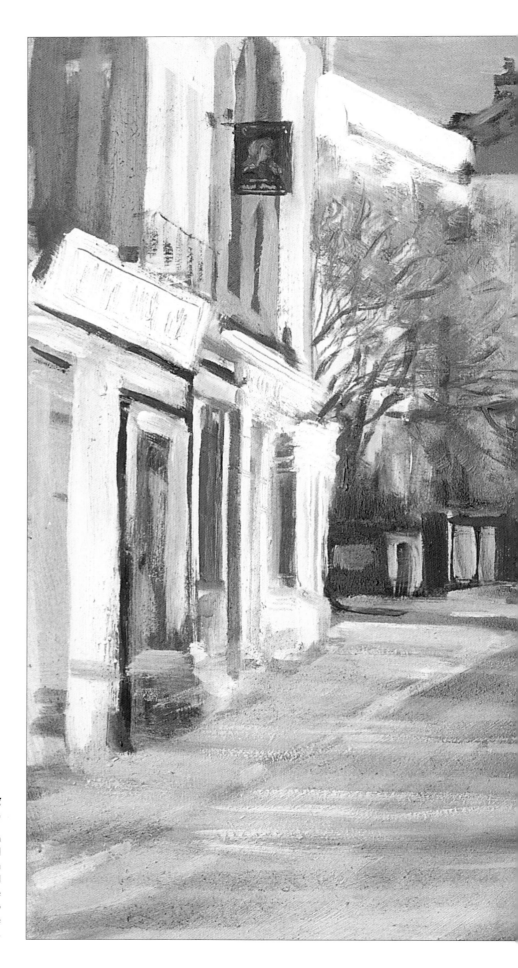

The finished painting

407 x 305mm (16 x 12in)

Although there is quite a lot going on in this painting, the glazes help to pull it all together and create a sense of unity. In following these steps you have used most of the techniques available to the oil painter, and allowed the painting to dry between the various stages in the traditional way.

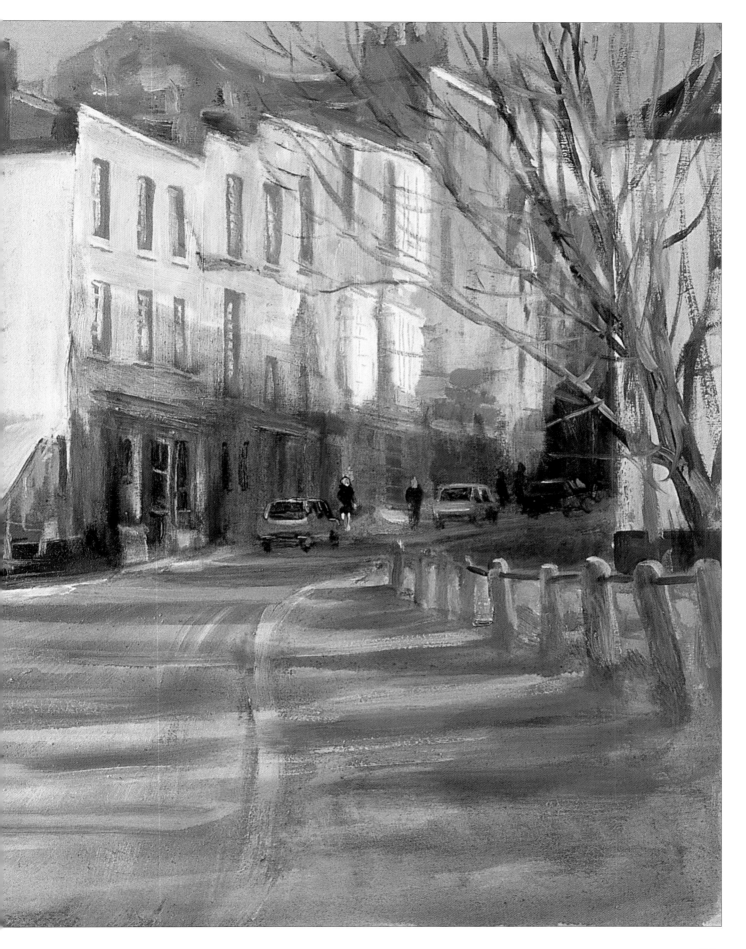

St Paul's Cathedral

254 x 305mm (10 x 12in)

Painted on a heavily textured background, this painting relies on the dramatic use of tone for its impact, with no attempt at adding detail.

Covent Garden Underground Station, London

305 x 380mm (12 x 15in)

This was painted quickly, at night, on site, using the light from an adjacent shop window to work by. The main difficulty was not the lighting but the attention of passers-by, who seemed to think I was a putting on some kind of performance for their benefit! Maybe I should have passed a hat round.

INDEX

acrylic paint 14, 44, 45, 58, 74, 86
alkyd gel 31, 64, 65, 74, 81, 86, 87, 88, 90, 91

boats 39, 43, 74, 77, 79, 80, 81, 85
brushes
 fan blender 12, 29, 64, 67
 filbert 12, 44, 51, 86, 90, 91
 flat 12, 44, 46, 47, 48, 50, 51, 58, 59, 60, 61, 64, 65, 66, 67, 68, 69, 74, 75, 76, 78, 79, 80, 81, 86, 88, 89, 90, 91
 household 44, 45, 64, 65
 round 12, 44, 45, 58, 61, 64, 66, 69, 74, 75, 80, 86, 87, 90, 91
buildings 56, 77, 78, 80, 81, 88, 91

colour
 complementary 19, 21, 22, 23, 28, 56, 62, 74, 85, 86
 limited palette 18, 20, 21, 44
 neutral 22, 23
 primary 18, 19, 21, 23
 secondary 19, 23
coloured ground 14, 64
composition 6, 19, 32–41, 43, 44, 64, 74, 86
 grid 35, 45, 46, 75, 86

easel 16, 53

fat over lean 10, 30
figures 74, 76, 79, 86, 91
flowers 43, 63
 daffodils 63, 64–71
focal point 34, 35, 40

glaze 41, 81, 90, 91, 92
grass 51, 64

horizon 25, 35

kitchen paper 17, 64, 65, 74, 76
knives 13, 52, 54, 72
 painting 13, 29, 44, 50, 64, 66
 palette 13, 45

landscape 19, 20, 25, 35, 43, 44
line 36, 40

oil paint
 alkyd 9
 mediums 8, 9, 10, 11, 28, 30
 traditional 8
 water mixable 9, 11

palette 16, 21, 22, 45, 51, 78, 79, 80
photograph 17, 37, 44, 52, 64, 71, 74
Pissarro, Camille 19, 43
primer 14, 83
 gesso 14, 21, 44, 45, 58, 74, 83, 86

rag, clean 17, 21, 28, 29, 44, 46, 86, 91
reflections 74, 77, 78, 80

sea 19, 73
shadow 31, 37, 53, 61, 73, 79, 86, 87, 89, 90
sketch 6, 17, 34–36, 37, 41, 43, 44, 45, 46, 56, 58, 73, 74, 75
sketchpad 17, 34, 44
sky 25, 29, 38, 46, 47, 66, 88
solvents 11, 17, 28, 29, 30
 low odour thinners 11, 44, 45, 58, 64, 65, 74, 75
 oil of spike lavender 11
 turpentine 11, 30
 white spirit 11, 30
still life 19, 27, 40, 43, 58–63
subject 34, 35, 58, 72

supports 14
 board 21, 29, 44, 45, 47, 58, 74, 83
 canvas 6, 14, 15, 24, 29, 30, 47, 59
 canvas board 14, 21, 64, 65, 86

techniques 26–31, 32, 43, 51, 59, 81, 83, 86, 89, 91, 92
 alla prima 28
 blending 29, 78
 blocking in 28, 30, 40, 45, 46, 47, 59, 60, 65, 66, 67, 75, 76, 77, 87, 88, 89, 90
 dry brush 30, 31, 91
 glazing 10, 31, 43, 81, 86
 impasto 28, 96
 layering 30, 31
 lifting out 29, 76, 91
 overpainting 28, 90
 scumbling 28, 30, 31, 59
 sgraffito 29, 51, 80, 83, 89, 91
 underpainting 28, 51, 59, 89, 91
 wet in wet 26, 28-29, 30, 86
 wet on dry 26, 29, 30–31, 86
tone 14, 28, 31, 36, 37, 40–41, 60, 61, 75, 76, 87, 88, 89, 94
townscape 35, 43

varnish 17, 31

The Gulls

305 x 254mm (12 x 10in)

I love painting dry stone walls with all their texture – an ideal subject for some impasto knifework! The focus of this little painting is the seagulls following the plough.

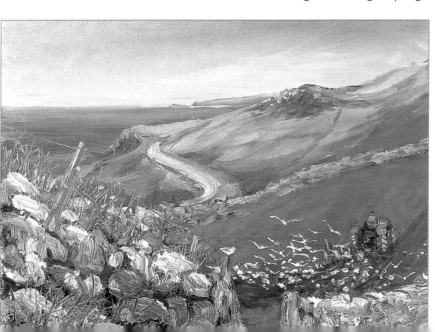